PRACTICAL
mixed-media
printmaking techniques

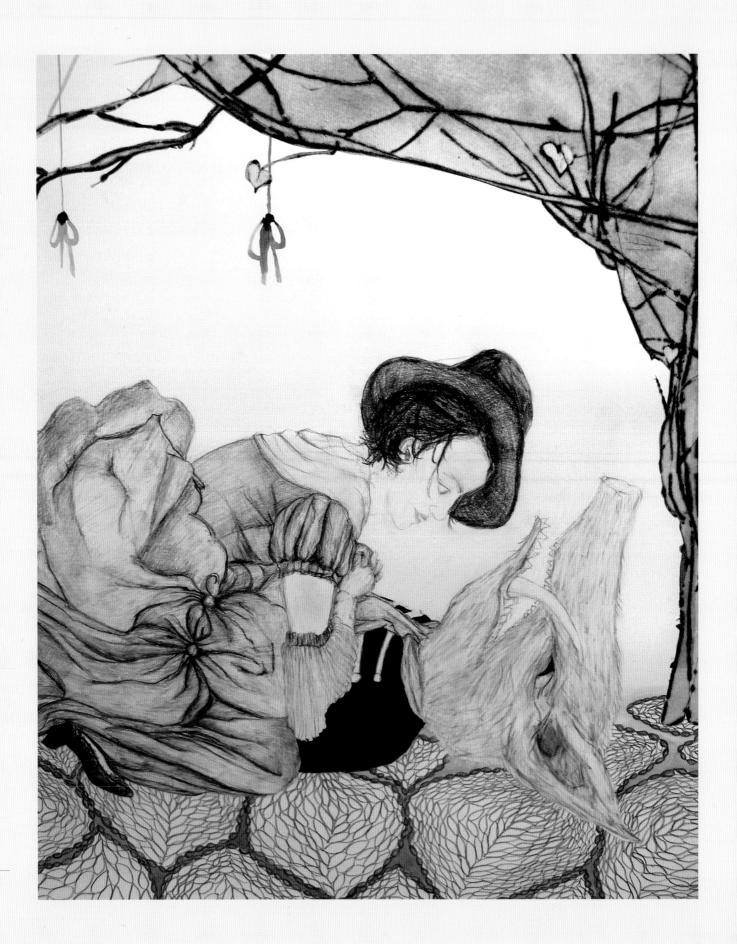

PRACTICAL

Mixed-Media Printmaking

SARAH A. RILEY

A & C BLACK • LONDON

Dedication

For Marc, whose writing on dance
is an inspiration.

First published in Great Britain 2011
A&C Black Publishers,
an imprint of Bloomsbury Publishing Plc
50 Bedford Square
London
WC1B 3DP

ISBN: 9781408127476

Publisher: Susan James
Series and cover design: Sutchinda Thompson
Page layout: Evelin Kasikov
Project editor: Davida Saunders
Copy editor: Fiona Corbridge

This book is produced using paper that is made from wood grown in managed, sustainable forests. It is natural, renewable and recyclable. The logging and manufacturing processes conform to the environmental regulations of the country of origin.

Printed and bound in China

Front cover
(ABOVE LEFT) Sarah Riley, *Violet Paget III*, 54.6 x 56 cm(21½ x 22 in.); (BELOW) Joe Riley, *Pressed Media*, 22.9 x 26.7 x 5 cm (9 x 10½ x 2 in.).

Back cover
(LEFT) detail of Joan Hausrath, *Egypt 2*, 12.7 x 17.8 cm (5 x 7 in.); (CENTRE) Sarah Riley, detail of *Marc's House II*, 38.1 x 55.9 cm (15 x 22 in.); (RIGHT) Sarah Riley, *Every Object I Could Compile*, 76.2 x 76.2 cm (30 x 30 in.).

Contents

Acknowledgements

THANKS TO ALL THE ARTISTS whose work has made this book a joy to write, especially Kathleen Shanahan and Marc Strauss, whose editing suggestions are only surpassed by their artworks. Thank you also to William Riley-Land, whose help on the index – actually creating a software program for it – made my job easier. And many thanks to my editor, Davida Saunders at A & C Black, for her invaluable suggestions, and to Elizabeth Kartchner for help with sizing, typing and editing.

Also, thanks to Castle Hill Truro Center for the Arts and its executive director, Cherie Mittenthal, for providing a print co-op and printmaking studio space, in which I developed some of the techniques for this book; and to the current registrar, Erin Woodbrey, and printmaking studio associate, David Ellis. I am grateful to Cyndi Wish, former head of printmaking and assistant director of the facility, for introducing me to that space. Thanks to Southeast Missouri State University for providing a spacious new printmaking studio in the Earl and Margie Holland School of Visual and Performing Arts on the banks of the Mississippi River, where I am fortunate enough to continue to experiment with, teach and print many of the techniques described within this book. Thanks to the current studio assistant, Liz Coffey, and former assistants Jim Daniels, Brian Flowers, Rachel Martin and Ed Haney. Finally, this book could not have been written without the help of Tanya Irby's accurate knowledge of university policies and procedures, which made chairing an art department while writing a book actually possible. Thanks to all of you.

Introduction

I HAD MANY GOALS IN WRITING THIS BOOK. One goal was to make art history, past and present, bigger and richer by bringing more guests, some still strangers, to the table of printmaking. Another was to ensure that the artists represented (both student and professional) refresh and promote what printmaking can be. I hope the unique juxtapositions of the wide variety of prints in this book will convey something useful to the reader: strangeness, beauty, weight, simplicity – something to take to your own work.

In terms of publications about and interest in printmaking, we are in the midst of a renaissance. The *Printmaking Handbook* series published by A & C Black are good examples of the many new printmaking books launched in the past few years, bringing us much-needed information about new processes and an updated look at traditional printmaking practices. Everything from stencilled graffiti to the wider spread of print processes in drawing, painting and sculpture is fuelling the renaissance. This book is a look at printmaking in the context of contemporary mixed processes, using low-toxicity techniques.

There are step-by-step instructions on making low-cost collagraphs (incorporating both intaglio and relief processes), drypoint on copper plate and Perspex plate, monoprinting from plastic sheets and Yupo, the use of inexpensive stencil materials, chine collé, polyester plate lithography, the use of digital images as layers in unique prints, and more. Clear descriptions of viscosity printing and registration techniques are included. My emphasis is on combining techniques, with a focus on creating variable editions or unique prints, and stresses low-toxicity preparation, materials and cleaning-up products.

The artists represented are primarily printmakers. There are also artists who pursue the rich language of mixed-media printmaking while working extensively in other mediums. I hope this book will be useful to those who are new to the subject, mature printmakers who want to take their work in new directions, and to teachers and students at secondary and university levels.

1 Collagraphs and beyond

COLLAGRAPHS ARE CONSIDERED TO BE A FORM OF INTAGLIO (from the Italian word meaning 'to cut into') because lines and textures are created on a matrix or plate to hold ink, which is then transferred to paper in the same manner as for etching, drypoint and engraving. The intaglio or collagraph plate may also be relief-rolled in the manner of traditional woodblock printing. Both intaglio-wiping (ink is held in incised lines and textures after the surface of the plate has been wiped) and relief-rolling (ink is on the surface of the plate; incised lines are ink-free) may be used interchangeably – and are often used together, juxtaposing and combining different colours and viscosities of ink for rich visual effects.

Collagraphs are a truly malleable and adaptable printmaking medium. They can be as simple (construct, ink and print in one colour) or as complicated as you wish (construct, ink in multiple colours, and add chine collé [see pp.56–8] and other processes before, during and after printing).

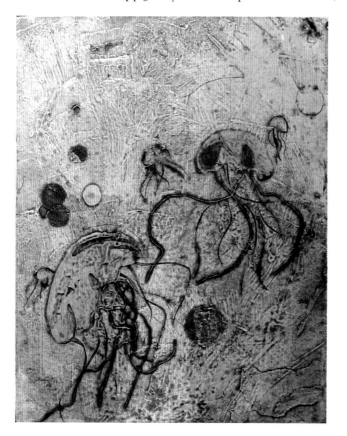

Plate for Liz Coffey's collagraph, *Fuse*. In this plate, the textures were created with gesso and gels on a matrix of illustration board. The plate was both drawn into and built up with the two mediums. The plate was scratched into (drypoint) with an etching needle after it had dried. Threads were used for the tentacles.

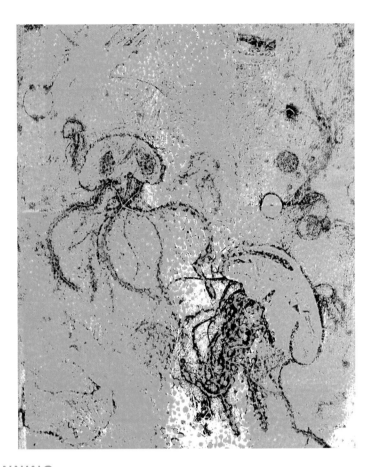

Liz Coffey, *Fuse*, 27.9 x 38.1 cm (11 x 15 in.). Note that the printed image shows both an intaglio wipe of purple and relief-rolls of yellow and green.

PRINT PLANNING

Give some thought to the way you will proceed when making collagraphs and mixed-media prints. If you are a beginner, create a small collagraph plate no larger than about 20 x 25 cm (8 x 10 in.), and try a variety of the suggested techniques. If you have printmaking experience, you can plan a mixture of techniques and sequences. You may choose to work on the printmaking paper before you actually print it, employing photocopy transfers and drawing.

PHOTOCOPY TRANSFERS

You may want to start a layered piece by transferring photocopies or laser prints to the printing paper. The process uses a solvent in the form of a natural citrus cleanser and degreaser based on d-limonene, such as Citra-Solv concentrate. It is important to note that inkjet prints will not work with this method: use only toner-based prints from a laser printer or photocopies. Note that most solvents (acetones) and wintergreen oil also work for this technique but are more toxic.

Good ventilation is a must with Citra-Solv, and it is a mild skin irritant, so wear gloves and safety goggles. It is combustible in its concentrated form, so always follow the cautions on the container. Use the Citra-Solv or other

solvent to transfer toner-based prints and photocopies to surfaces with an etching press, or by hand using a rubbing tool. You may need to experiment to find the process that works best for you. Both techniques work best with fresh photocopies or laser prints, and with images that have a good degree of contrast (too much grey in a print and not enough white will make the transfer difficult to decipher).

Some news-magazine images transfer well using this technique: you will need to experiment. The process also works on some types of wood and cloth (most print processes are compatible with printing on cloth). Choose the grain of the wood or the weave of the cloth with the complexity of the image in mind. A complex, detailed image will demand a more closely grained wood or tighter weave of cloth than a simple image. Follow the instructions as below, using a baren on wood. When transferring by hand on to cloth, use a slightly padded surface, and then stretch and hold the cloth in place with pins. You may also find it helpful to wash the cloth first to remove any sizing or starch from it, thus making it more absorbent.

MAKING A PHOTOCOPY TRANSFER

1. Place the printing paper on a piece of smooth Perspex (Plexiglas), which is on the press, and position the photocopy face-down on top of the paper. (This works on both damp and dry paper.) The Perspex is important, as you need the flat, smooth surface of the acrylic sheet to help the photocopy to transfer most completely.

2. You may want to secure the photocopy in some way to ensure that it doesn't move during the transfer process. Try printing the photocopy on a sheet of paper large enough to extend beyond the print paper, so that you will be able to tape it to the press or the print registration package (see p.31).

3. Rub the back of the photocopy with a piece of tissue or a cotton wool ball dipped in the solvent (or paint on a very small amount) until the photocopy becomes transparent (too much solvent will create a muddled image). The toner will start to transfer almost immediately. Wait about ten seconds before placing newsprint over both and running everything through the etching press. Carefully check the image and, if it is too faint, tighten the pressure and run the print through the press again. CAUTION: Never force the press with too tight a pressure setting. You can always finish the transfer by hand.

YOU WILL NEED

MATERIALS

- Citra-Solv concentrate, wintergreen oil or a solvent like acetone
- Smooth piece of Perspex (Plexiglas in the US)
- Sheet of printing paper
- Fresh photocopy or laserprint
- Masking tape

TOOLS

- Piece of tissue or cotton wool ball
- Baren, bone folder or wooden spoon
- An etching press

TIP IF THE PRINTING PAPER IS TEXTURED, TRY RUNNING A DAMPENED PIECE THROUGH THE PRESS, FACE-DOWN ON THE PERSPEX, AT LEAST ONCE TO FLATTEN IT AND TO MAKE IT MORE RECEPTIVE TO THE TONER-BASED IMAGE.

4. Alternatively, transfer the image by hand. Tape the photocopied image to the paper along one edge, so it won't move and so that you can check it often as you work. Rub the back with a tissue dipped in a small amount of solvent, until it becomes transparent. Wait about ten seconds and rub the back of the image with a baren, a bone folder or a wooden spoon. You may need to add a bit more solvent as you work on the transfer, but usually 'less is more' with this process.

TIP ALWAYS MAKE SEVERAL PHOTOCOPIES OR LASER PRINTS OF YOUR IMAGE IF YOU PLAN TO USE IT FOR A MIXED-MEDIA EDITION.

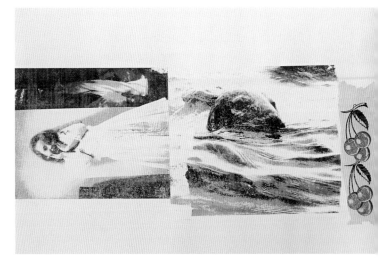

ABOVE Sarah Riley, *Cultural Invention*, toner transfer and chine collé, 38 x 56 cm (15 x 22 in.). This seemingly simple print involved many steps of preparation. Before cropping and laser-printing the images to be used for the transfers, they were manipulated in Photoshop, using Levels and various filters in order to exaggerate the contrasts of value and to emphasise the related flowing forms of water and dress fabrics.

How do we read photographic images? Even the taking of a photograph involves complicated intuitive and learned responses to subject matter. The juxtaposition of seemingly random images can be manipulated in a formalistic as well as in a narrative way. The viewer brings his or her own informed history to an interpretation. The textural incompleteness of the transfer sets a mood. The addition of the old wallpaper image of cherries adds another narrative layer.

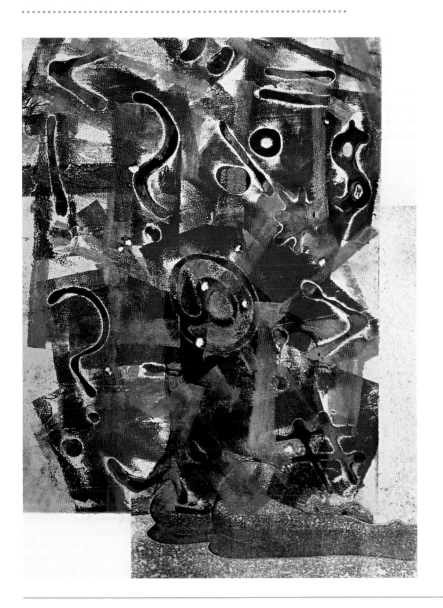

LEFT Edward Haney, *Isolation*, 28 x 38 cm (11 x 15 in.). 'Suicidal thoughts begin with the idea of isolation and that nobody understands how you feel. The figure is an image transferred from a copier print with Citra-Solv. The symbol plate was a ghost print of black with red and silver roller marks. These represent the warning signs of suicide. The holes are from a .22-calibre rifle, the most used firearm for committing suicide.' This print, from a series on AIDS and suicide, employs crude jabs of the inked roller as if they were reverberations from the rifle shot. The jabs of the roller were placed on an intaglio-inked and -wiped collagraph plate before printing.

DRAWING BEFORE PRINTING

Try experimenting by making drawings in permanent Indian ink and acrylic, or Indian ink washes, on the printmaking paper prior to creating a plate. Think about the way that the drawing or wash and the print will come together. When the paper is soaked prior to printing, the ink and/or acrylic will not be disturbed.

In the section on printing (see pp.30–1), I will describe how to print plates using inking techniques of two or more colours per plate. Start thinking about colour layers of transparent and opaque inks; also about layering a print with additional plates, drypoint plates (see pp.72–83), stencils (see pp.61–2), monoprints (see pp.40–5) and chine collé (see pp.56–8) as described in subsequent chapters.

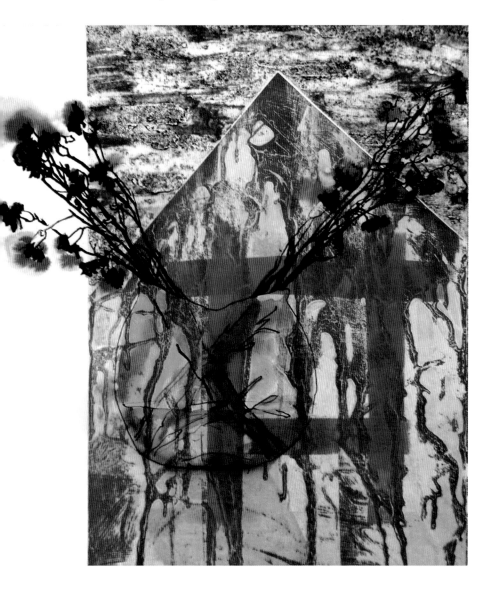

Sarah Riley, *Violet Paget III*, variable edition. Collagraph over drawing in permanent Indian ink, 54.6 x 56 cm (21½ x 22 in.). For this print, I used Strathmore Aquarius II watercolour paper, which is made from a combination of cotton and synthetic fibres that work well with water-based techniques as well as oil-based printmaking inks. Compared to other papers of the same weight (170 gsm/80 lb), the strength of the paper and its ability to dry with minimal buckling and swelling make it ideal for this combination of techniques.

The two plates for the print were made on a matrix of inexpensive illustration board. I used Liquitex Black Lava Effects Medium, Liquitex Ceramic Stucco Effects Medium, Speedball Screen Filler, and gloss and matte acrylic polymer mediums to create texture. The plates were inked and wiped as an intaglio plate and then relief-rolled with a less viscous ink. This was the third printing of the plates from a single inking, making it a ghost print. The bottom plate was relief-rolled again before the third printing, as it had lost too much ink from the two previous printings. Before printing, a narrow roller was used to roll an orange square directly on to the lower collagraph plate. The plates were printed over the permanent Indian ink and wash drawing of the flowers and vase.

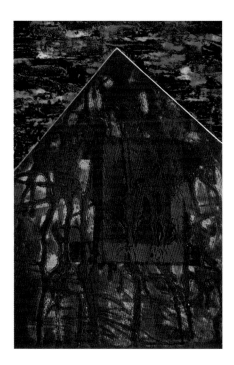

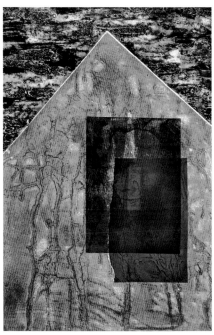

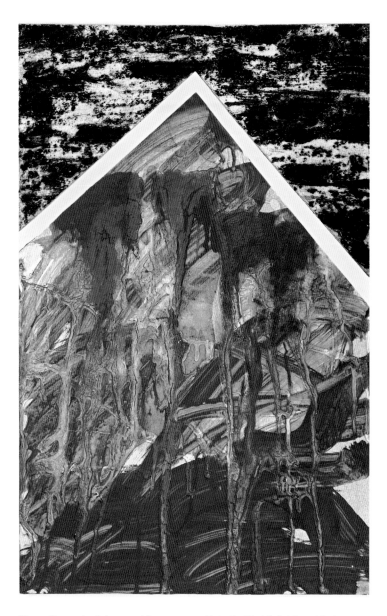

Sarah Riley, *Violet Paget I and II*, variable edition, each 56 x 76 cm (22 x 30 in.). These two prints are from the first and second printings of the same collagraph plates as *Violet Paget III*. They include the use of chine collé, viscosity printing (see pp.34–5), monoprinting and a third etched metal plate.

The collagraph plates used in the *Violet Paget* prints. On these collagraph plates, the different mediums hold ink differently. The dripped gloss medium can be wiped very clean, whereas matte medium will hold a tone, as will the brick-coloured Speedball Screen Filler. Since the plate was relief-rolled after being intaglio-wiped, the cleaner areas of the gloss medium held most of the freshly rolled ink. On the top plate, the highly textured lava and stucco gels, applied in an undiluted state, hold a lot of ink and print a rich black.

Note that in *Violet Paget I*, the top plate was inked as an intaglio with black before being relief-rolled with an opaque medium-grey ink of lower viscosity. The darker green/purple square of paper is chine collé. The overprint of pink and orange inks changed colour on top of the green chine collé.

In *Violet Paget II*, an older etched copper plate of *Violet Paget (Vernon Lee)* was registered and printed partially over the green paper chine collé.

MAKING A COLLAGRAPH PLATE

A collagraph plate consists of a base plate with additions to the surface to hold ink and create lines and textures. It is best to keep the plate very thin. The finished plate surface build-up should be no more than approximately 0.3 cm (1/8 in.) thick in order to print well, to facilitate drying time and, most importantly, to protect the etching press and blankets. Thicker plates, with several levels, can be made for viscosity inking (see pp.34–5), but start with thin plates until you learn the process. Even a thin plate can be successfully inked with several colours and viscosities of ink.

The basic process for making a collagraph plate is to prepare the base plate (cut it to size and seal it if necessary), create the design on it, allow it to dry, seal the plate, allow it to dry thoroughly and then ink and print.

YOU WILL NEED

MATERIALS

- Mounting board (also known as matboard in the US), illustration board or Perspex (Plexiglas) for creating the base plate
- Acrylic polymer gloss medium (for dripping, gluing, drawing and sealing base plate)
- Acrylic polymer matte medium
- Screen filler
- Variety of acrylic gels such as heavy gel medium, lava gel or stucco gel
- Carborundum grit and sand (mix with a clear-drying gel to create your own texture gel)
- Caulks and wood putty
- White glue, yellow carpenter's glue or PVA glue
- Gesso
- Materials to add to or impress into plates (see box)

TOOLS

- Applicators such as a syringe without the needle, or squeezy bottles filled with thick gesso, acrylic medium, glues or gels (to create lines)
- Texturing tools such as sticks, forks, screws, pizza-cutters, etching needles (for drawing and scoring into wet and dry gesso)
- Scissors
- Scalpel, utility knife and single-edged razor blades
- Variety of brushes, and a palette or putty knife (for applying textured gels)
- Small containers or cups (for mixing/containing gesso and glues and for saving inks)

Creating texture

Many materials can be applied to a plate to produce interesting textures. Here are some ideas to experiment with:

Plastic wrap and aluminium foil. These are good for texturing gessoes, gels and glues.

Masking and other tapes. These can be used to create lines and shapes on the surface of the plate. Any raised area or surface texture will hold ink and print if inked and wiped correctly.

Fabrics. Use to create different tones and textures. Sandpaper glued directly to the plate's surface can also be used to create tone.

PREPARING A CARDBOARD BASE PLATE

Many of the practices used to reduce toxicity in etching and screenprinting can be applied to the creation of collagraphs. Acrylic polymer medium can be substituted for the toxic oil-based shellacs and varnishes previously used in making and sealing collagraphs. Acrylic resists oil and oil-based inks quite well.

It is also not necessary to use metal, rigid plastic, wood, Masonite (or other types of pressed board) as a substrate for a collagraphic print. For unique prints or when working in small editions, heavy card mounting board (matboard) is sufficient as a support for glued papers and textures of various thicknesses. These materials, sealed with quick-drying acrylic mediums, create a durable matrix.

Consider the ease with which you can use mounting board, illustration board or solid cardboard to create shaped plates, or several plates that fit together for a final print. The one in the *Violet Paget* prints above was cut into two pieces to allow for a very different inking of the top and bottom parts of the print. Together, the shapes evoke a house or a geometric intrusion of some sort into a stormy, sky-like area.

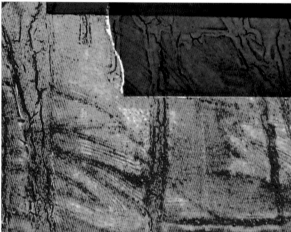

Cover pieces of your chosen board, front and back, with acrylic gloss medium. Note that brushstrokes created with the acrylic medium will print (see close-up below). This, of course, may be perfectly desirable and can give direction, movement and texture to the print. If you do not want brushstrokes to show, spray an acrylic medium on both surfaces of the cardboard plate and allow it to dry prior to creating lines and textures. Refer to the instructions on the can to ensure proper ventilation when spraying any acrylic medium.

You can see, in the close-up image, that the smallest variation in height can create a texture or line in the final print. Great variations of depth on the surface of a plate are not necessary unless you wish to fully explore viscosity printing.

TIP CORNERS OF PAPER BOARD PLATES ARE VULNERABLE; DROP A THIN METAL PLATE OR MASONITE BOARD ON ITS CORNER AND YOU HAVE THE SAME PROBLEM. YOU CAN, HOWEVER, REPAIR THE DAMAGED CORNER OF A PAPER BOARD PLATE BY WRAPPING IT CAREFULLY WITH MASKING TAPE AND COVERING WITH GEL OR ACRYLIC MEDIUM.

Close-ups of brushstrokes on the *Violet Paget* plate and the same section from the prints: *Violet Paget I and II* (the first printing of the plates and the first ghost print). Note: printed images are the reverse of the plate.

The more simplified the process of collagraphy, the more possibilities open up and the more spontaneous and engaging it becomes. Plates that are created in this way can last through as many as 10–30 or more printings. They are easy and quick to cut, assemble, seal and clean. Oil-based inks print cleanly from a dry surface sealed with acrylic medium.

TIP PRINTMAKING IS ABOUT CONTINUAL EXPERIMENTATION. EVERY TIME YOU CREATE A PLATE OR PRINT, WRITE DOWN WHAT YOU DID IN AS MUCH DETAIL AS POSSIBLE. IN THE FUTURE, YOU CAN REFER TO THESE NOTES TO JOG YOUR MEMORY ABOUT THE TECHNIQUES YOU USED. SOMETIMES THESE JOURNALS – WITH SAMPLE SMEARS OF INK, BITS OF PAPER, DRAWINGS AND NOTES – BECOME WORKS OF ART IN THEMSELVES.

PREPARING A PERSPEX (PLEXIGLAS) BASE PLATE

If you wish to use Perspex as a matrix, select a thickness of 0.3 cm or less and file and/or sand sharp corners and edges. Avoid having any thick, sharp edges that will cut and ruin the printing paper and the expensive press felts. The thinner the Perspex, the less need there is for filing and sanding edges. You will also need to sand the flat surface of the Perspex with fine sandpaper in areas where you wish to adhere other materials. Keep it in mind that sanding will add a tone to the surface of the plate, as the sanded areas will hold some ink. Also, any scratches on the Perspex will print as lines.

TIP AN ADVANTAGE OF USING PERSPEX (PLEXIGLAS) AS A MATRIX IS ITS TRANSPARENCY. BEING ABLE TO SEE THROUGH THE PLATE TO A DRAWING, PLAN OR PRINT BENEATH CAN HELP IN CREATING A DESIGN. IT CAN ALSO ASSIST YOU IN REGISTRATION WHEN YOU PRINT.

The Perspex plate created for the *Full Moon* series. This plate was sanded selectively before applying the areas of gesso and glue. You can see the lines scratched into the gesso after it had dried. This is a type of drypoint technique.

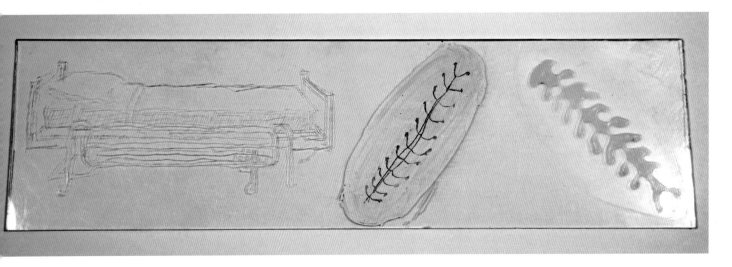

Sarah Riley, *Full Moon*, 3/3, variable edition. Drypoint, collagraph and chine collé, 38 x 56 cm (15 x 22 in.). Note the way that the central ovoid image, created with gesso, holds a tone as well as darker lines. This is a good example of the way that a medium which dries with a matte, rather than glossy finish holds more ink or tone. On the left-hand side, the fishbone or suture-like area was created by drawing with white glue. White glue tends to spread out. If you want a finer, more controlled line, use a thicker gel or even acrylic paint squeezed from a squeezy bottle (like the one below). This print also includes a piece of hand-stained rice paper for chine collé (see pp.56–8).

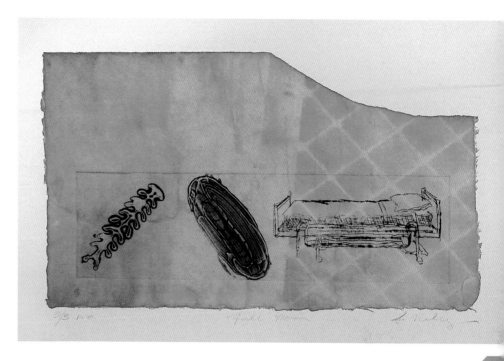

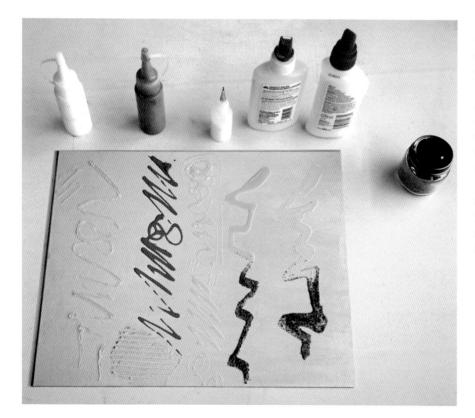

Different types of squeezy bottles and the types of lines they create. This plate was made from a piece of mounting board which was sealed on both sides with gloss medium. Lines were made with (from left): acrylic gloss heavy gel medium, acrylic paint, acrylic gloss medium, wood glue and white glue. While the glues were still wet, they were dusted with sand about halfway down the plate. There is an area of Liquitex Light Modelling Paste below the orange acrylic lines, which has been scored with a plastic serrated tiling knife. When you look at the proof of this test plate, remember that the image will have been flipped.

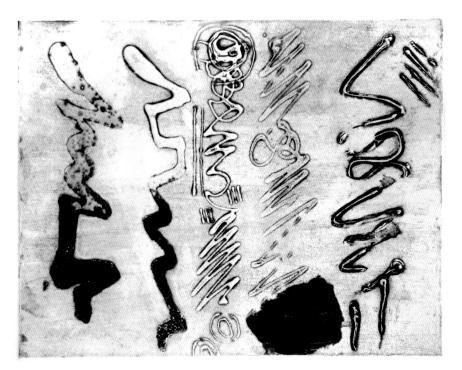

Proof from test plate. Note that the lines which have not been dusted with sand wipe clean because they have a slick surface. Ink defines the lines on either side. The area of light moulding paste has held a lot of ink because of its rough texture. White glue is very vulnerable to damp printing paper in the printing process: it starts to dissolve quickly and will stick to the paper, so always seal it with acrylic polymer medium. Wood glue, acrylic paint, gels and mediums are very solid when dry. When applied to a slick surface, however, acrylic gel squeezed from a tube in a thin line may tend to pull away. It helps to sand beneath it and/or to apply a good coat of acrylic medium to seal everything after it has dried.

Do not coat unworked surfaces of a Perspex plate with acrylic medium. Perspex has a smooth surface which, when left clear of texture, will wipe clean before printing. You can also leave areas of the acrylic sheet clear for drypoint image-making. The hospital bed in *Full Moon* was created with drypoint. In other words, the plastic was scratched into with a sharp needle tool, raising a burr, which then held ink for printing.

If you wish to glue things on to a Perspex plate, or to work its entire surface, sand the whole surface. Start with a circular motion and sand from the centre of the plate out to its edges. Do not coat the plate with acrylic medium at this point. Seal the surface after you have glued on the textures or painted it with different mediums.

TECHNIQUES FOR BUILDING A COLLAGRAPH PLATE

Pick from a range of basic techniques to apply different degrees of texture, and for creating areas that will hold ink, like an aquatint. Use a liquid medium to draw a design if you wish. Remember that the build-up on the plate should be no thicker than approximately 0.3 cm (1/8 in.). This will make inking and printing much easier and the plate will dry faster.

HEAVY TEXTURE

Apply gesso, lava gel, stucco gel, or other texture gels and gel mediums to the plate with brushes and palette or putty knives to create varying textures and areas of value.

You could also create your own texture gels by mixing sand, coffee grounds or carborundum grit into gel mediums or screen filler. Carborundum with a grit size of 120 or 320 holds ink well. For rich blacks, sprinkle it on areas of the plate after applying gels, gessoes or glues. Shake the plate after it has dried to clear it of any non-adhered particles. Save these particles, as they may be reused.

The advantage of lava gel or a carborundum and gel mixture is that black flakes are suspended in the medium. This allows you to see an approximation of the density of ink that the texture will hold. The fewer the black flecks, the less ink will be held by the texture, and the less ink you will print. Use water to thin.

TIP WORK WITH CARBORUNDUM GRIT AND SAND AWAY FROM INKING AREAS, AS YOU DO NOT WANT THE GRIT TO CONTAMINATE THE INK AND SCRATCH THE SURFACE OF THE PLATE.

The top plate used in the *Violet Paget* series was painted with lava gel and an acrylic ceramic stucco gel. The lava gel contains bits of tiny rock-like substances, giving it a grainy texture that holds ink well. The bottom plate was painted loosely with screen filler. Note that even those thin, loose strokes read well in the final print. On top of the brushstrokes of screen filler, I dripped additional screen filler and acrylic gloss medium.

LIGHT TEXTURE

Drip, splatter and paint matte and gloss mediums and screen filler on the surface of the plate. These materials do not need to be applied thickly. Remember that almost any change to the surface will print if the plate is wiped correctly.

DRAWING A DESIGN

Squeeze gesso, glues or gels through an applicator tip to 'draw' images, lines or shapes.

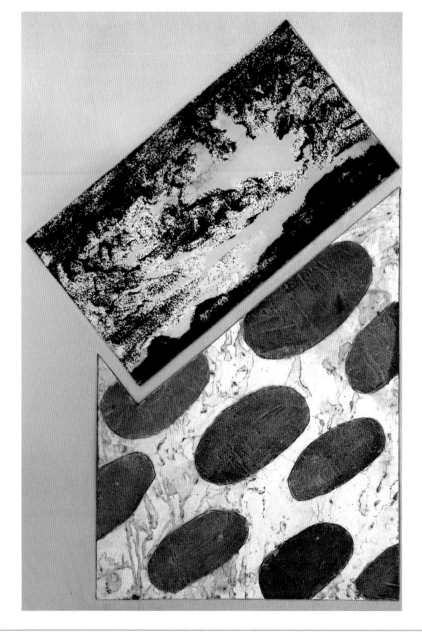

The cardboard collagraph plates for the *Full Moon* series. These plates were created with a base of illustration board, stucco gel for the ovals, and Liquitex Black Lava Effects Medium was diluted and painted on the top plate.

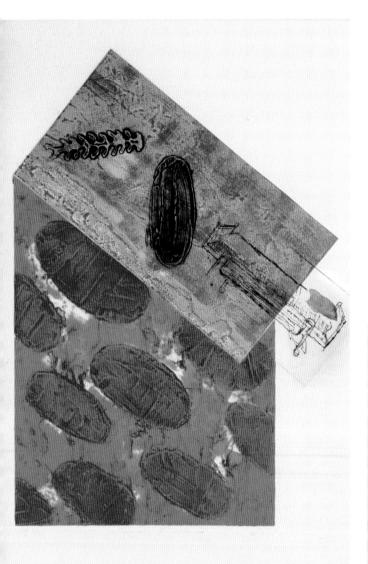

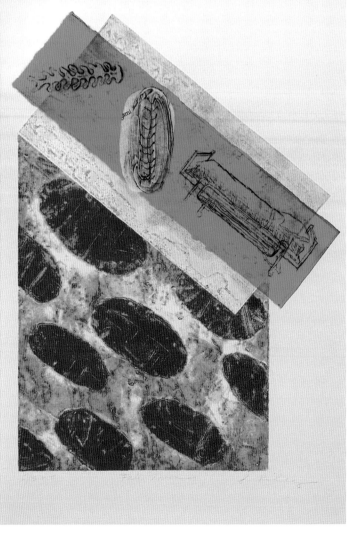

Sarah Riley, *Full Moon*, 2/3, variable edition. Drypoint, collagraph and chine collé, 38 x 56 cm (15 x 22 in.). The plates were printed a second time without re-inking. This second printing is a paler version and is called a 'ghost print'. When reprinting, a piece of hand-stained green rice paper was used for chine collé under the collagraph plates. Then the Perspex drypoint and collagraph plate was printed (along with an oval piece of white rice paper under the oval shape).

Sarah Riley, *Full Moon*, 1/3, variable edition. Drypoint, collagraph, 38 x 56 cm (15 x 22 in.). The larger plate for this print was intaglio-inked with red and relief-rolled with an opaque pink. The upper, smaller collagraph plate was intaglio-inked in yellow and relief-rolled with a green. The Perspex drypoint/collagraph plate (seen above) was then printed over the top part with a dark blue intaglio ink.

USING DRAWINGS AND PHOTOCOPIES AS GUIDES

If you are working on a transparent base plate, you can put a drawing, photo or photocopy beneath it and use it as a guide for mark-making. If you wish to use a photocopy or drawing as a guide on an opaque plate, glue the image directly to the plate. Draw lines over it with a squeezy bottle. It can be sealed later with acrylic medium.

Photocopies may also be used to create stencils through which acrylic polymer mediums may be scraped, creating shapes and silhouettes that will hold ink.

TIP USE A GLUE STICK TO ADHERE AN IMAGE GUIDE TO A PLATE. IT CAN BE DONE QUICKLY AND THE PAPER WILL NOT WRINKLE AS IT MIGHT WHEN USING A WET GLUE OR MEDIUM.

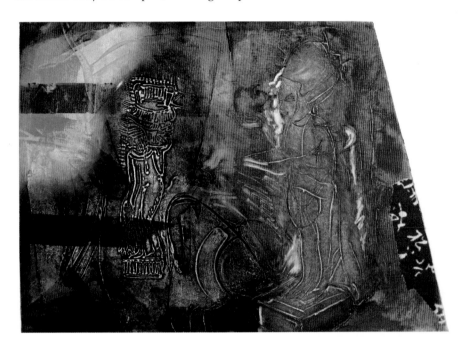

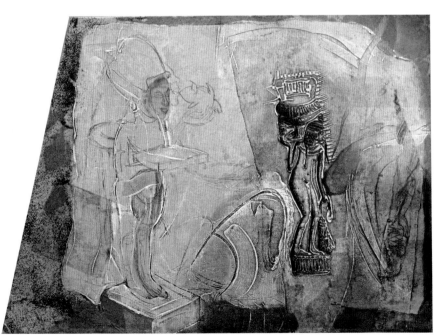

Kathleen Shanahan, *Amphora Akhenaton II*. Collagraph, monoprint, drypoint and chine collé, 40.5 x 58.5 cm (16 x 23 in.). Print and plate shown.

Note the loose application of gesso and gels with a palette knife and brushes in the close-up of the plate for ***Amphora Akhenaton***. 'Amphora girl' (the figure on the right-hand side of plate) was drawn with white glue directly over a photocopied image, which was glued directly to the mounting-board plate with a glue stick.

In the close-up of the plate you can also see that mounting board layers were scored with a scalpel and some were lifted or torn to reveal substrata. In addition you can see, in the faces and figure to the left, that lines were scratched into the surface with a sharp point (drypoint technique). The plate was inked with various colour zones and blended at the connecting boundaries.

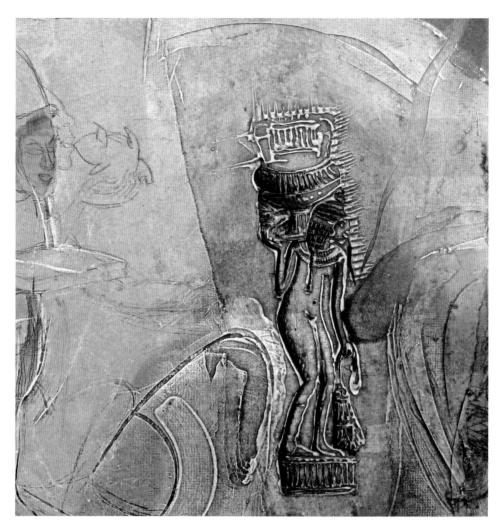

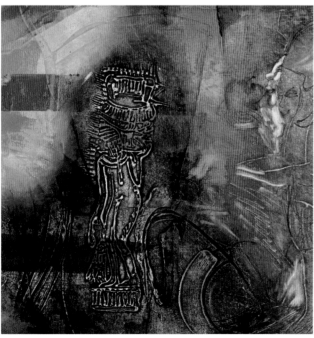

In the print itself, you can see that roller passes were made over the surface before printing. Note the dark lines on either side of the white glue drawing of the figure with the amphora. The top of the drawn glue line was wiped clean during the intaglio-wiping process, leaving the ink along either side. You can see also how the top of the glue lines picked up the relief-rolls of red and yellow ink.

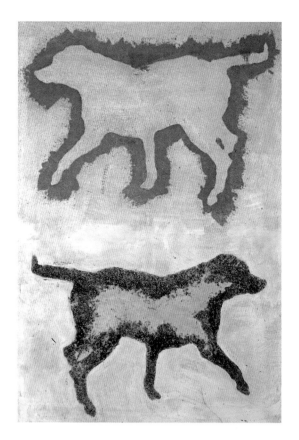

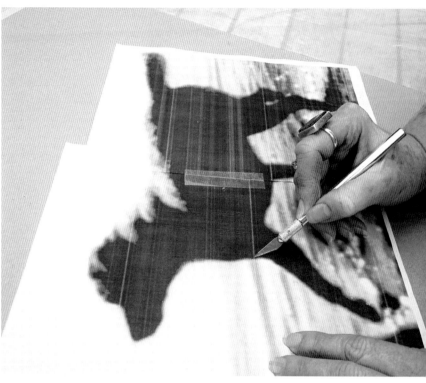

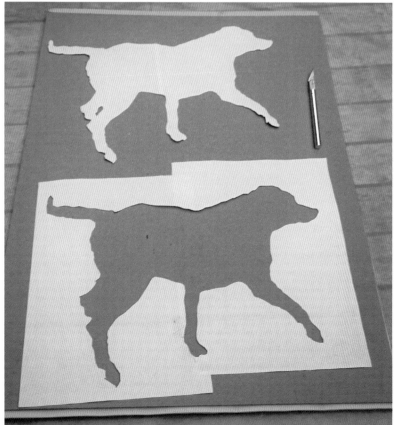

To create the two-dog plate, a stencil was cut from a printout of a scanned and enlarged photograph. Both the positive and the negative stencils were used to create the collagraph plate. For the top image of the dog, stucco gel was scraped over the positive stencil with an old credit card. For the bottom one, lava gel was scraped inwards from the negative stencil. The texture gels were allowed to dry for about 15 minutes before the stencils were carefully removed. It is necessary to remove the stencil while the acrylic gel is still damp, or the stencil might adhere to the plate.

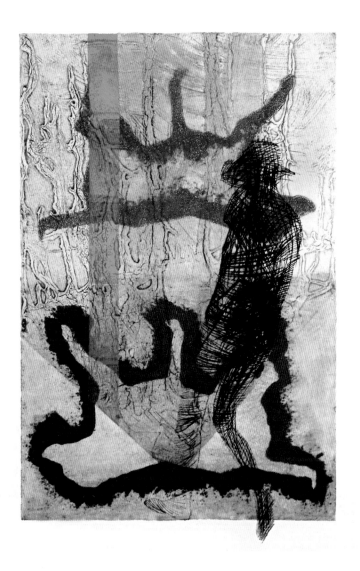

Sarah Riley, *Alchemy I*, variable edition.
Collagraph and drypoint, 56 x 76 cm
(22 x 30 in.). The dog plate was used for a
series of images including this one, which
incorporates two collagraph plates, viscosity
inking and a drypoint plate. One of the
collagraph plates from the *Violet Paget*
series was reused in an inverted fashion
over the dog plate print. The turquoise stripe
was rolled on to the collagraph plate with
a narrow roller.

MORE WAYS TO BUILD TEXTURE AND LINE

1. Embed fabrics into acrylic gels, mediums or gesso for different textures
or greys. The fabric's texture will hold the ink needed for printing.

2. Embed a sandpaper shape in one of the above mediums so that it will
hold ink. The rougher the sandpaper, the more ink it will hold – thus, the
darker the impression.

3. Use sandpaper to create textures on the surface of a plate. Lightly sanded
Perspex will print as a light tone.

4. Glue some cut or torn mounting board to the surface to create shapes
and textures.

5. To create interesting effects, remove surface layers from a mounting
board plate. Try tearing, scraping and cutting the surface.

6. To create lines, draw into the mounting board with a sharp nail or an etching needle. You can seal it later.

7. Cut or tear masking tape into shapes and apply it; it can also be stuck on in strips to create lines.

TIP YOU MAY ALSO WANT TO TRY PRINTING A PAPER-BOARD PLATE WITHOUT SEALING IT. CONDITION THE PLATE FIRST WITH LOW-VISCOSITY BURNT COPPER PLATE OIL. RUB ALL THE SURFACES LIGHTLY WITH A COAT OF OIL TO PREVENT DAMP PAPER FROM STICKING TO ANY UNSEALED OR UN-INKED SURFACES AS IT ROLLS THROUGH THE PRESS. CAUTION: SOME PEOPLE USE ANTI-SKINNING SPRAY, WHICH HELPS PREVENT INK FROM DRYING ON THE INK SLAB OR FROM FORMING A SKIN IN THE TIN, TO CONDITION OR EVEN TO SEAL A COLLAGRAPH PLATE, BUT BE AWARE OF THE INGREDIENTS IN THIS PRODUCT AND USE GOOD VENTILATION.

8. Experiment with acrylic materials: screen filler will hold a grey tone, as will gesso and matte medium. For areas that will be lighter, gloss mediums can be wiped clean easily.

9. Gesso, when dry, is a good surface to scratch into, like drypoint on metal. For softer lines, make marks with forks etc. in gesso or gel while it is still wet. Most types of gesso do not need to be sealed with an acrylic medium before inking. You may wish, however, to cover selected areas with gloss medium to lighten the tone or value.

TIP TRY EMBEDDING PLANT MATERIALS INTO GESSO OR GEL TO LEAVE AN IMPRESSION, REMOVING THEM BEFORE THE MEDIUM SETS COMPLETELY.

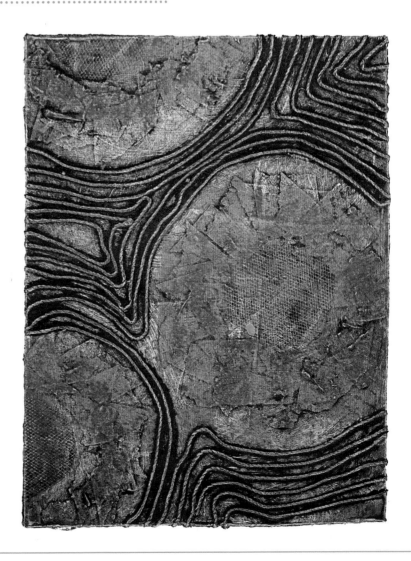

Ashley Sites, **# 4**, collagraph with viscosity inking, 20 x 25.5 cm (8 x 10 in.). With this simply constructed plate of masking tape, string and netting, an elegant formal print has been created. This plate was intaglio-wiped with a brown/black etching ink and then viscosity-rolled with transparent turquoise and orange inks.

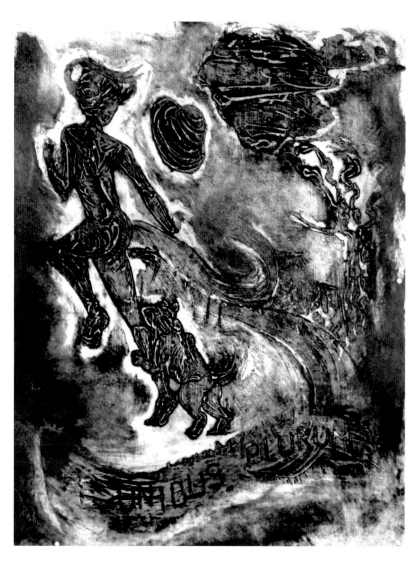

Plate for *Curious Youth*.

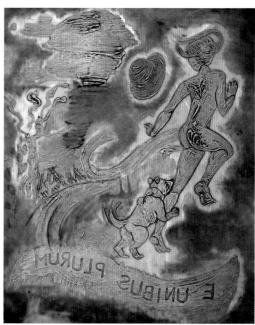

Norm Hahn, *Curious Youth*, collagraph
and drypoint on Perspex, 45.7 x 58.4 cm
(18 x 23 in.). The plate for this print was a
matrix of thick Perspex (Plexiglas) covered
entirely with gesso, gels and glues that
were manipulated with a putty knife while
wet. Dry, they were scratched, scored and
scraped into in order to create lines, shapes
and textures.

ARTIST PROFILE

DOUG BILLINGS

Doug Billings works primarily in stone and polyester plate lithography, but also incorporates solar plate printing, relief printing, collagraph, drypoint, monoprinting and stencilling into his prints. 'Most of the prints that I have done in the past four years have focused on the city of Wichita: its local landmarks, public art and its developing downtown/old town areas. Since this is my primary environment, I wanted to incorporate it into my images, but in a way that would say something about me and my relationship to Wichita as well as play around with the subject to hopefully create some surprising and thought-provoking compositions.'

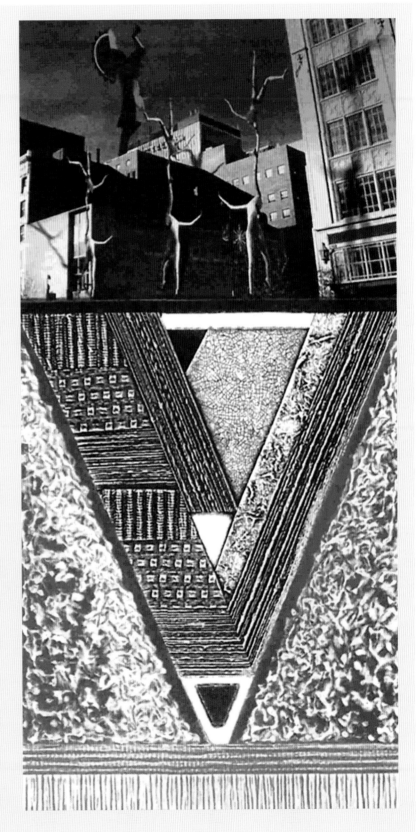

Doug Billings, *Wichita Composition 3*, 17.8 x 35.6 cm (7 x 14 in.). The lower part of this composition is a collagraph made from sandpaper, various wallpapers and glue. The top section is printed in black from a solar plate on top of a split or rainbow roll (see pp.62–6). Two colours of ink were blended together using a roller until smooth and then rolled on to a piece of mounting board. The mounting board then became the matrix from which the blended colours were printed as a background for the solar plate.

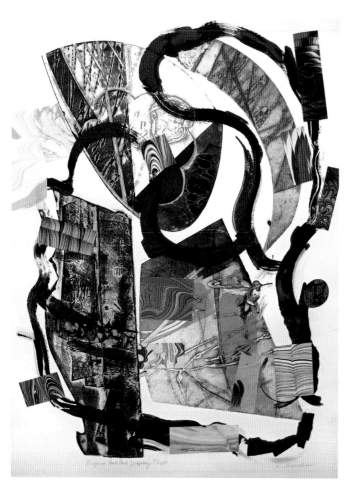

LEFT Kathleen Shanahan, **Rufus Red Bud Display Flight**, 53.3 x 41.9 cm (21 x 16½ in.). The processes here were: collagraph (the two black and green areas were intaglio-wiped with black ink and then relief-rolled with green; the green and blue shape in the centre and the yellow and orange crescent shape are also irregularly shaped cardboard collagraphs), monoprint (note the loose scrapes of black and red etching ink made with an old credit card), hand-painting (the red hummingbird, centre right), collage (small square pieces of marbled paper), and a small amount of collaged metallic foil.

BELOW Detail of **Rufus Red Bud Display Flight**.

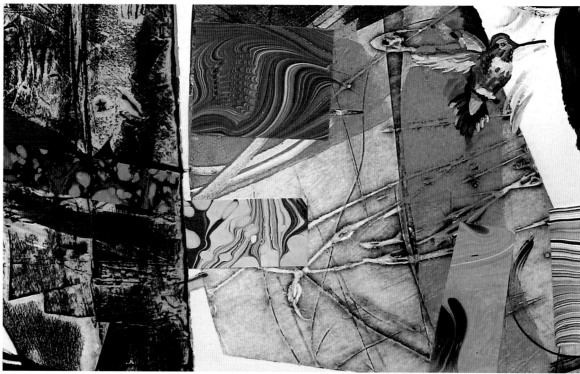

SEALING AND FINISHING A PLATE

Most plates need to be sealed when you have finished building them. Always cover anything such as tape, fabrics and lace with acrylic medium to seal it. (It is important to experiment when building a plate, but use soft materials – nothing that is thick, hard or sharp and which could ruin expensive felts or even more expensive presses.) You can usually tell if something will stick to damp printing paper or be pulled away from the plate during the process of inking and wiping.

Another way of sealing a fairly uncomplicated plate of securely glued-down board and paper shapes is to apply a light rubbing of a thin burnt copper plate oil before inking. Letting the ink dry on a plate of this type after it has been printed also creates a seal and thus extends the life of the plate. However, if you fix many small or complicated textures and things to a plate, these must be glued down securely and sealed with acrylic medium. Otherwise, you may be picking small pieces of the collagraph from the surface of the print, or the damp printing paper may even stick to the collagraph plate. Let the plate dry overnight. Plates need to be totally dry before printing. If the glues and gels on a plate have not dried thoroughly, they will stick to the damp printing paper when you roll it through the press. If you apply too much pressure or the printing paper is too damp, it can also cause the paper to stick to a textured plate. White glue, especially, softens quickly when exposed to damp printing paper, and the paper will easily stick to it if it has not been sealed with acrylic medium, shellac (button polish) or some type of varnish. Remember that even the slightest variation in surface thickness or material will print. Keep surface textures low and make sure they are not sharp.

TIP EVEN DRY, SEALED PLATES CAN STICK TO DAMP PAPER UNDER CERTAIN CONDITIONS, SO IT IS GOOD PRACTICE TO CONDITION A PLATE WITH OIL BEFORE INKING. (THE IDEA OF WATER AND OIL REPELLING ONE ANOTHER IS A GOOD ONE TO KEEP IN MIND.) WIPE OFF EXCESS OIL BEFORE APPLYING INK.

Extra notes on sealing plates

Though there are many materials one can use to seal a collagraph plate, the use of acrylic/polymer medium is the easiest and involves the least toxicity. It is durable for the purposes of a shorter edition, or for reusing in unique prints using multiple techniques. Some people prefer shellac (button polish), which dries relatively stroke-free. You may also want to use spray shellac or acrylic for a stroke-free finish; some people use acrylic or polyurethane varnish. Read labels carefully for best practice in keeping the work environment healthy for you and others. Use products such as shellac with proper ventilation and away from others, or use a ventilated spray booth.

PRINTING A COLLAGRAPH PLATE

Once your plate is sealed and dry, try printing it with one colour of ink in the intaglio manner (see pp.32–4). The inital printing will give you ideas about developing the image further with a second colour applied as a relief roll. Alternatively, consider ways to break up or organise the image with sections of chine collé. If you are incorporating the chine collé process (see pp.56–8), you will need coloured and/or textured rice paper (or other thin papers). These may be tinted with thinned acrylic paints or permanent inks (and then dried) prior to using.

MATERIALS FOR PRINTMAKING

Before printing choose a paper especially suited to printmaking, such as Rives BFK, Arches Cover, Somerset or Hahnemühle Etching.

Also have on hand a basic set of etching inks: process magenta, yellow, cyan, black and white will produce a full spectrum of colour mixtures. You will also need some transparent base in case you want to increase the transparency of a colour.

EQUIPMENT FOR PRINTING

Always wear gloves when handling inks. Look for fitted vinyl or plastic gloves, or buy a pack of disposable, surgical-type gloves. Baby powder is useful to keep gloves from sticking to your hands, making them easier to get on and off. Dust your hands with the powder before putting them on, and when you take them off, shake some powder into the gloves to make them easier to put back on later.

You may like to use old metal etched plates, or

YOU WILL NEED

MATERIALS

- Coloured and/or textured rice papers (for chine collé, optional)
- Printmaking paper
- Etching inks in various colours and transparent base
- Reducing oil/jelly or Easy-Wipe Compound
- Burnt copper plate oil
- Magnesium carbonate

TOOLS AND EQUIPMENT

- Printer's apron
- Fitted vinyl or plastic gloves, or disposable surgical-type gloves
- Baby powder
- Print registration package
- Old printing plates (optional)
- Inking slab
- Putty knife
- Ink daubers made from rolls of felt
- Various sizes and densities of rollers
- Scrim (tarlatan) cloths for wiping plate
- Old phone books, newsprint or tissue paper
- Soft cotton rags

Ink additives

Reducing oil/jelly and Easy-Wipe Compound (an ink additive made by Graphic Chemical in the USA, and available in the UK from T. N. Lawrence & Son – www.lawrence.co.uk) make the plate easier to wipe by reducing the tack of the ink but not its body. Tack Reducer Gel is an alternative to Easy-Wipe Compound (available in the UK from, among others, Intaglio Printmaker: www.intaglioprintmaker.co.uk). A light Burnt copper plate oil can be used to loosen inks, making them less viscous. This and litho varnishes (boiled linseed oil) range from light to thick as you move from #000 to #8. Some printmakers also use Flash Oil 470 to change the viscosity of inks for viscosity printing. If you need to make an ink more viscous, add a small amount of magnesium carbonate powder.

thin, previously carved linoleum blocks or woodblocks to print over your new prints.

You will need a selection of scrim (tarlatan) cloths for wiping the plate. Scrim is a loosely woven cotton cloth rather like stiff cheesecloth.

MAKING A PRINT REGISTRATION PACKAGE

The print registration package ensures that plate and printing paper will register correctly each time you print. To make it, use a piece of heavy acetate, or polyester sheet such as Mylar or Dura-Lar (polyester sheet does not stretch under pressure), and a piece of stiff backing paper or card, such as poster board or thick cartridge paper (a type that has a grid is helpful). Both the clear, flexible sheet and the white backing piece should be at least 2.5 cm (1 in.) larger on all sides than the printing paper. For a piece of printing paper such as Arches Cover, which measures approximately 56 x 76.2 cm (22 x 30 in.), you will need a registration package of at least 61 x 81.3 cm (24 x 32 in.). Tape the two pieces together along one long side and use this print package for plate registration (and some monoprint techniques). Because Dura-Lar has been treated to hold a wash, it can also be used for watercolour monoprint techniques (see p.48).

REGISTRATION AND SOAKING THE PRINTING PAPER

On the paper backing of the print registration package, mark where both plate and paper are to be placed (prior to inking the plate and soaking the paper). Use an 'X' to mark one corner of the registration guidelines. Also, mark the same corner on the back of the printing paper and the plate. This way, you will know how to register both, in the correct relationship, for any subsequent layers of printing. As paper swells when it is soaked, it is important to mark where you will place the corner marked with an 'X' and its two adjacent sides on the print package.

Soak heavy rag printing paper in water for 5–30 minutes before blotting it and placing it over the inked plate for printing. Soaking softens and removes sizing, a starch-like substance that reduces a paper's ability to absorb liquids. Stiffer papers with more sizing, such as Stonehenge, may be soaked for longer.

After soaking, place the paper on a sheet of upright Perspex and gently squeegee it to remove some water; or hold the paper above the soaking tray by one corner and allow water to drain from it. Then place the wet paper between sheets of blotting paper or cotton bath towels. Use a roller or your hands to press the upper layer on to the wet paper to absorb the excess moisture. Paper should be evenly damp; not wet and not shiny.

TIP TAKE OFF YOUR GLOVES BEFORE YOU TOUCH THE PAPER OR THE PRESS. YOUR HANDS, THE PAPER, THE PRESS AND THE FELTS WILL REMAIN FREE FROM INK THIS WAY. PUT THE GLOVES BACK ON BEFORE RE-INKING THE PLATE OR WORKING WITH INKS IN ANY MANNER. IF SOME INK SHOULD INADVERTENTLY GET ON YOUR HANDS, DUST THEM WITH BABY POWDER TO KEEP THE INK FROM MOVING OFF YOUR HANDS TO OTHER SURFACES.

TIP A DROP OR TWO OF WASHING-UP LIQUID IN THE SOAKING WATER WILL KEEP THE WATER FRESH FOR LONGER.

Preparing printing papers for printing

Paper made of 100 per cent rag, containing cotton and/or linen fibre, is acid-free and recommended for printmaking – it will not discolour and deteriorate over time. However, any acidic paper that is in contact with it will burn and discolour it. That is why you should always mount your prints using acid-free board. (If you are not interested in the archival qualities or longevity of your prints, a wide variety of papers may be used for printing. Experiment with everything from used envelopes to making offset prints on hard surfaces.)

Waterleaf papers such as Arches 88 (no internal or external sizing) and thin papers such as rice paper need only to be lightly sprayed with water to prepare them for printing. Enclose the spritzed paper in plastic, so that the dampness can spread evenly throughout before printing. Handmade paper without sizing may disintegrate if dipped in water, so test it before soaking. Heavy, 100 per cent cotton rag printing papers are sized and need to be soaked for 5–30 minutes, depending on the depth of the plate. The paper will soften and swell so the press and blankets will be able to push it into the depths of the plate. A good paper for deep embossing is Fabriano Murillo. Most printmaking and paper suppliers provide guidelines for paper selection on their websites. Daniel Smith has a good printable one at www.danielsmith.com.

INKING, INTAGLIO-WIPING AND PRINTING THE PLATE

1. Put on your gloves and work and mix the etching ink on an inking slab (a piece of glass or Perspex) with a putty knife to loosen it. If you want to increase the transparency of an ink colour, add transparent base first, then pour in a small amount of reducing oil or Easy-Wipe Compound, or burnt copper plate oil, to make the ink easier to wipe from the plate. You may also add burnt copper plate oil to make the ink looser for viscosity printing (see below). Use magnesium carbonate powder to stiffen the ink if required.

2. Roll out a portion of ink on the glass slab with a soft roller and then roll the ink on to the plate. This, along with a dauber used to push the ink into the depths of the plate, works better than a piece of stiff card on heavily textured areas. You will use less ink this way.

3. After working the ink thoroughly into all areas and textures of the plate, scrunch the wiping cloth (scrim/tarlatan) in your fist, shaping it into a rounded form by gathering the fabric under while also creating a smooth surface. (As you work, use scrim that is impregnated with ink first and move on to cleaner pieces as you wipe off more ink.)

TIP SWITCH TO BLANK NEWSPRINT OR TISSUE PAPER FOR THE FINAL WIPE IF YOU NOTICE THAT THE PHONE BOOK PAGES ARE LEAVING TINY SPECKS OF BLACK INK ON THE PLATE.

4. Wipe the plate in a light, circular motion, as you would an etched metal plate. To wipe rough areas like carborundum, press the cloth down and turn it a bit as you lift it off the plate. Pay attention to the outer edge areas of the plate, as these tend to be under-wiped by the beginner. You are aiming for an even plate tone (or no ink on smooth areas) while leaving ink in the lines and textured areas of the plate.

5. Finally, polish and even out tone with flat phone book pages, newsprint or tissue paper. To help prevent the plate from moving, hold it on the worksurface with one hand placed flat on a piece of phonebook page or newsprint while the other hand, held flat on another phone book page, very lightly moves in a circular motion. Keep moving often to a cleaner area of the phonebook page. Use the other side and other sheets as needed.

ABOVE Applying two colours of ink to a single plate. Use a piece of stiff card to apply ink to areas of a plate that are not highly textured. Use a roller and then a dauber to work the ink into deeper and rougher areas of the plate. When working with more than one colour, keep the colours divided by an area of clean plate until the very end of the wiping process.

1 After applying the ink, work it into the plate with a dauber.
2 Shape the scrim wiping cloth into a flat-sided ball shape.
3 Wipe each colour separately with a different piece of scrim (tarlatan).
4 Keep different colours separate until the very end. The two colours are lightly blended at their boundaries during the final wiping with phone book pages or pieces of tissue paper.

6. Finally, wipe the edges of the inked plate with a clean, soft rag before placing the plate on top of a sheet of newsprint on the press or, preferably, the print registration package (see p.31). (This will ensure correct registration with the printing paper and subsequent layers, as well as leaving the surface of the press clean for the next person.) At this point, remove your gloves in order to handle the paper and press with clean hands.

7. Place the soaked and blotted printing paper in place over the plate, using registration guide-marks previously made on the print registration package.

8. Always place a sheet of clean, dry, unwrinkled newsprint over the paper before covering with the press blankets and cranking through the press. See 'Further Notes on Printing' on p.37.

Further notes on inking

• After inking the plate, you may wish to try wiping off certain shapes or areas with the thinnest burnt copper plate oil (polymerised printmaking oils are less damaging to paper than regular linseed oils), and then ink and wipe those areas with a different colour.

• With a small roller, roll freehand shapes or stripes of a second colour on the wiped plate.

• *À la poupée* (with a dolly): Alternatively, you can apply different colours of ink to different sections of a plate with your fingers, a roller or stiff, clean-cut pieces of card and daubers, or bunched-up pieces of cloth (the dollies). Then carefully wipe each area in such a way that the colours are kept separate and only merge at their edges.

VISCOSITY INKING AND VARIATIONS

Developed originally at Stanley William Hayter's Paris Studio, Atelier 17, viscosity printing allows for the printing of several colours of ink from one plate. This process involves first inking and wiping a plate in the intaglio fashion. Then the surface is rolled with another colour and viscosity (thickness or stickiness) of ink for contrast and to bring out the upper (relief) surface of the plate/image. Afterwards, a third and fourth colour of ink may be added. The different viscosities of ink will repel one another to a degree. Ideally, the plate will have various levels to receive the different inks. Viscosity inking works well with collagraph plates that have many textures and levels, and the results are often surprising.

Ideally, the rollers used will vary in hardness, which is measured with a durometer in shores: generally from 70 or 60 shore, the hardest, down to

20 shore (durometers in the US), the softest. By varying the hardness of the rollers, you can reach different depths on the plate. There is obviously a lot of scope for play in varying the traditional sequence of rolls and viscosities of ink, doing partial rolls, altering the transparency or opacity of the ink, and using colours that complement or contrast.

WORKING WITH VISCOSITY INKING

The traditional process is as follows:

1. Apply the first layer of ink and intaglio-wipe it. This layer is not modified, but, if it seems fairly loose, you may want to add some magnesium carbonate to stiffen it. You can still add a small amount of reducing oil or Easy-Wipe Compound to this. Follow the instructions on pp.32–5 for intaglio-wiping the plate. This layer of ink will be the stiffest or of the highest viscosity.

2. Apply the second layer, of another colour of ink, with a hard roller, 35 shore or above, using the loosest ink (lowest viscosity). You can modify the ink with flash oil 470, burnt copper plate oil, or litho oil/varnish (boiled linseed oil) – #00 to # 3 are good choices for softening the inks. This second layer should be the most 'runny'. Using little or no pressure, relief-roll the plate with this ink. This roll will hit the highest parts of the plate. Ideally, the roller should be wider than the plate.

3. The third layer, another colour of ink, should be of a medium viscosity (some oil added, but less than to the second layer). Using a soft roller, apply this layer with some pressure so that it reaches the lower levels of the plate.

4. A fourth layer, if desired, may be added by rolling out a fourth colour of very thin ink on a glass slab. Turn the plate over on to the inking slab and hit or press the back with your hand. The highest parts of the plate will receive some colour. Print as usual.

. .

TIP GENERALLY, APPLY LOOSE, LESS VISCOUS INKS OVER STIFFER INKS AND THEY WILL REPEL ONE ANOTHER. THE LOOSER INK IS REJECTED BY THE THICKER INK AND ADHERES TO THE PLATE IN PLACES NOT COVERED BY THE FIRST. YOU NEED NOT STICK WITH A STRICT FORMULA, AS MANY VARIATIONS OF VISCOSITY INKING WILL PRODUCE INTERESTING RESULTS. WITH MIXED-MEDIA PRINTMAKING, THE RESULTS CAN BE MODIFIED WITH SUCCESSIVE LAYERS OR EVEN CUT UP AND COLLAGED INTO ANOTHER PRINT.

. .

ARTIST PROFILE

ISOLINA LIMONTA

Born in Guantanamo in 1956, now residing in Havana, printmaker Isolina Limonta is one of the most prolific artists of her generation in Cuba. She studied at the art academies 'San Alejandro' and ISA in Havana. Her work is stunning, with its rich colours and textures. In addition, there are underlying deep social observations. Her printmaking reflects a strong influence from the traditional Afro-Cuba religion, Santeria. The bodies of the figures in her work are often filled with the intimate elements of their lives – plants, coins, feathers, architecture, lace and buttons (to name a few).

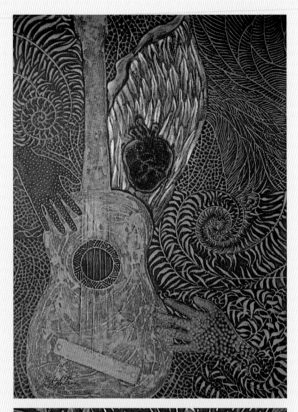

TOP Isolina Limonta, *Mis Acordes* (My Chords), hand-embellished collagraph on paper, 94.6 x 61 cm (37¼ x 24 in.). From the collection of Mary Ann Villanueva and Eric Sears. Photographer: Michelle Wojcik, Galeria Cubana, Boston/Provinceton. The deep, lush colour and the sweeping movement of tropical vegetation create a deeply engaging image. Isolina attributes Cuban artists Choco (Eduardo Roca) and Nelson Domínguez as the first to introduce the technique of collagraphy in Cuba. Limonta's process of collagraphy includes a cardboard matrix measuring 0.2 cm. *Blanco de España*, a zinc compound, is mixed with water and wood glue to form a paste, which can then be applied with brushes and a spatula and manipulated when it hardens with a chisel tip or mint. After one or two days of curing, different textures (dried leaves, branches, found metal, fabric, wire etc.) were firmly attached to the matrix to obtain the desired composition. The print was intaglio-wiped in some areas and inked à la poupée and with a roller in others. The print was also hand embellished with acrylic paint after drying.

BOTTOM Isolina Limonta, *Untitled*, collagraph, 4/15, 57.8 x 41.3 cm (22¾ x16¼ in.). From the collection of Richard Grandoni. Photographer: Michelle Wojcik, Galeria Cubana. Areas of the matrix for this print were created as for *Mis Acordes* (above). Different areas were inked *à la poupée* and then carefully intaglio-wiped. The top surfaces were relief-rolled and brushed with ink. Note the whisper of emerald green being blown from the golden head.

FURTHER NOTES ON PRINTING

If the plate is excessively uneven in depth, place foam rubber or thick, soft paper such as blotting paper over the newsprint, paper, plate and print package to protect the felts and the press before cranking the print through. This will not only protect the press, but it will help to press the paper into the depths of the plate. (Upholstery foam sheeting works too. If it is thick enough – about 2.5 cm (1 in.) – you can use it instead of press blankets to print collagraph plates that may be too uneven for the regular press blankets/felts.)

Modern presses will feel as though they are using a light pressure when you crank them. They are, however, adjusted in such a way as to exert a lot of pressure. If it feels difficult to roll the plate and paper through the press, then it is too tight. Stop and readjust the pressure. You do not want to force or break an expensive press. Adjust the pressure up or down depending on your needs. For instance, ghost prints (second printings of a collagraph or monoprint plate) will need more pressure than you used for the original print.

You can check the quality of a print image by leaving one end of the paper and print package locked in place under the roller and blankets while carefully lifting a corner to review a small section of the print. Your hands should still be clean, as you removed your gloves after inking and wiping the plate and before touching the paper, press or anything on it. If necessary, lower the paper and blankets back into place, adjust the pressure, and run everything through the press again to remove more ink from the plate.

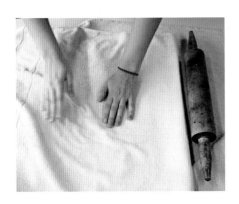

Blot soaked and drained paper with cotton bath towels (or blotting paper), using a roller or your hands.

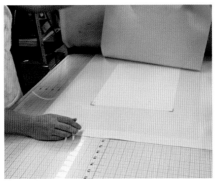

Print and printing paper are placed on the print package at the markings; this is covered with clean sheet of newsprint

Smoothing the press blankets individually over the print package.

Jordan Schaaf adjusting the pressure. Test the plate, print package and paper at some point prior to inking the plate. Make a note of the pressure in your printmaking notebook, so that when you are ready and it is your turn at the press, you will know what setting to use. Pressure should be adequate, but it should never feel difficult to crank a print through. You need much less pressure than you may think. Never crank a press that feels tight: excessive pressure can break an expensive press.

Checking the print. Note the marks for the placement of the paper on the print package. Place an 'X' at one corner of the print package and on the back of the matching corner of the printing paper. Do the same with the plate. You should then be able to register the plate and paper, placing them exactly as before, for successive layers.

Another print was pulled from the same plate without re-inking. This is known as a ghost print. It is often possible to pull more than one ghost print. See the Violet Paget prints above and the next illustration.

At this point, you may still want to leave the end of the paper and the print package tucked under the roller and pull back the print, placing it over the roller and blankets. You may now place another plate on the print package, using the previously drawn registration marks. Alternatively, you may wish to remove the print from the plate and the press in order to see where to go next. The beauty of the print package is that it has markings for plate and paper so that you can register successive printings on the same sheet of paper.

If you are not ready to print another plate, you may want to wrap the print in plastic sheeting to keep it damp; or simply let it dry and re-soak and blot once you are ready to print the next layer. You have the markings on the print package to guide you in placing the next plate and the paper.

Another way to register and print a second layer from a different plate is to register it by sight (or 'eyeball' it). Place the sizing catcher blanket, then the print package (or a piece of clean newsprint) flat on the press. Place the damp print face-up and then position the next plate (eyeballing it into place), before covering the whole lot with a sheet of clean newsprint, and the rest of the blankets; run through the press.

CLEANING THE INK SLAB AND TOOLS

1. For cleaning an ink slab and tools, a number of solvents may be used, but all you really need is vegetable oil. Better still, mix the vegetable oil with 20 per cent washing-up liquid. This is a trick that printmaker Kristin Nowlin introduced me to.

2. Squirt the washing-up liquid/vegetable oil mixture on the ink slab, rollers and tools after having scraped off as much ink as possible from the slab using a putty knife or scraper. Let the mixture sit on the ink for a few minutes to dissolve it.

TIP THE CHEAPEST VARIETY OF COOKING OR SALAD OIL THAT YOU CAN FIND WILL WORK WELL FOR CLEANING PLATES, INK SLAB AND TOOLS. IT IS ALSO NON-TOXIC.

3. Roll any inking rollers through the mixture on the slab. Let it soak into the ink on the roller for a minute or two and then clean the roller by rolling it on newspaper or used sheets of newsprint. A final wipe with a soft rag should be enough to remove any residue. You may also wish to use a sponge and water, or even rinse the roller with water (as the mixture contains soap, it will help to remove the remaining oil).

4. Clean the remaining ink off the slab with old newspapers or sheets of used newsprint.

5. If you are using plain vegetable oil, give the inking slab a final wipe with rubbing alcohol or a window-cleaning solution. If using the detergent/oil mixture, you may even be able to clean off the residue with a sponge and water. This same cleaning process may also be used with relief and litho inks.

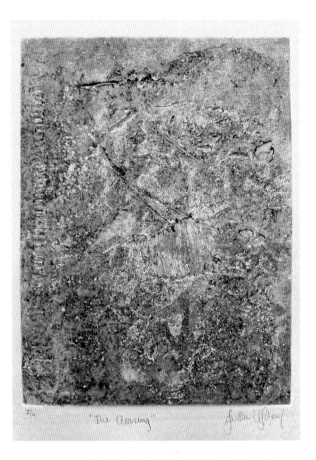

Jordan Schaaf, *The Clearing*, collagraph, 28 x 36 cm (11 x 14¼ in.). The same plate that was used in the preceding prints was relief-rolled with a very transparent magenta, then a burnt sienna of a different viscosity, and was run through the press with slightly more pressure for a third time. Viscosity printing generally gives interesting – even thrilling – results.

Cleaning a collagraph plate

To clean a collagraph plate, simply run it through the press several times on to blank sheets of newsprint. If deep crevices do not come clean, use vegetable oil or baby oil and a toothbrush. Let the oil sit on the surface for a few minutes to soften the ink before wiping it off. Cleaning up in this way does not break down the surface of the plate.

Don't use alcohol, chemical solvents, or all-purpose cleaners such as Dettol, Mr Muscle or Simple Green to clean plates sealed with acrylic medium, as they may ruin them. Also, don't wash, rinse or soak the plates in water, as it can soften the acrylic polymer surface and spoil the plates.

2 Monoprinting

MONOPRINTING IS A PAINTERLY WAY of creating a print or of adding to an existing print. If a print uses no existing, repeatable matrix, it is referred to as a monotype. Any flat surface can be used to create a monoprint in the traditional manner. Or any material (try waxed paper or plastic sheeting) can be pressed into ink (or have ink applied to it in some manner) and then in turn be pressed on to paper through a press or by hand. Try rolling etching ink on the surface of Mylar or Dura-Lar (clear polyester sheet), or Perspex (Plexiglas), and then subtract ink using any materials or tools at hand. Add to the plate using brushes and etching ink, oil paint thinned with burnt copper plate oil, or even solvents if you are working in a well-ventilated space away from others. The following suggestions primarily describe ways to use monoprinting to add to mixed-media prints.

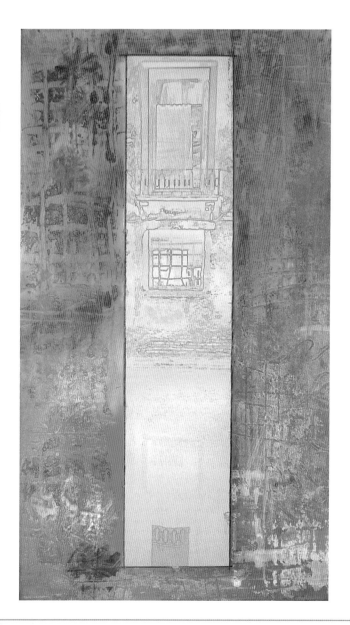

Sarah Riley, *Venice Reflection*, 43.2 x 76.2 cm (17 x 30 in.). The central image of the window and reflection is from a photo reworked in Photoshop with Filters (specifically Filter ⋯⟩ Stylise ⋯⟩ Glowing Edges; the image was then inverted under Image ⋯⟩ Adjustments ⋯⟩ Invert) and Levels (Image ⋯⟩ Adjustments ⋯⟩ Levels). The window image was then printed on Arches hot-pressed watercolour paper, (250 gsm/140 lb), using an Epson Stylus Color 1520 printer. I used this heavy watercolour paper because I knew I would also be applying water-based Indian inks. After applying some barrier lines of waxy Prismacolor pencil around the central image, I painted permanent acrylic inks in washes on the border area. The coloured pencil helped to prevent the washes of colour from overlapping into the photo area. While the painted colourwashes were drying, working on waxed paper, I rolled out some gold ink and worked into it subtractively with various tools and cloths to remove ink. The gold ink was printed (by simply pressing and rubbing by hand) on to the dry colourwashed border.

SUBSTRATES

You can use the print registration package as your plate or substrate, previously having placed registration marks for the plate and printing paper. Use the top transparent sheet for rolling ink, or use a brush to place ink on areas where you would like to make additions to a print. Keep in mind the reversal of the printed image. Alternatively, use a Perspex sheet for creating a monoprint layer. Unmounted linoleum and other soft blocks for relief printing may also be used as a matrix for monoprinting.

USING OFFSET PRINTS AS GUIDES

Since a print is a reversal of the image on the plate, you can use an offset (or counterproof) image from the print as a guide by putting it under a clear matrix – use the transparent top sheet of the print package. You could also use the original plate itself as a guide if it is thin enough. In addition you may trace the edges of the plate and major shapes on to tracing paper and use that as a guide beneath the transparent sheet.

To make an offset print, simply take the freshly pulled print, put it face-up on the press, place another piece of printing paper, newsprint or heavy tissue over it, and then run it through the press again. The image will be offset on to this second sheet of paper in reverse, and you can use this as a guide for your monoprint.

Register the offset image under the transparent sheet and place ink where needed, with brushes and rollers, on top – as long as you don't put ink on too thickly, you can paint and roll it directly on the transparent sheet and then print. After rolling the top of your print registration package with a thin film of ink, subtract from or add to it with rags, cotton buds and brushes. You can print again and again on the same piece of paper, registering successive layers of ink from your print registration package.

..

TIP YOU CAN USE BOTH ETCHING INK AND OIL PAINT THINNED WITH BURNT COPPER PLATE OIL TO CREATE A MONOPRINT. TOO MUCH INK OR PAINT, OF COURSE, CREATES BLOBS AND SMEARS. BLOT THE EXTRA INK OR PAINT WITH A PAPER TOWEL OR OTHER ABSORBENT MATERIAL BEFORE PRINTING.

..

Try rolling dark ink on to the transparent sheet and subtract it in areas. Print this over a light area of a print. Conversely, try adding interest to a dark area of a print by monoprinting a tinted ink (white ink added; lighter in value and more opaque) over that area.

YOU WILL NEED

MATERIALS

- Mylar or Dura-Lar sheet, wax paper or plastic sheeting
- Perspex (Plexiglas)
- Etching ink
- Thin burnt copper plate oil (or solvents such as lithotine)

TOOLS

- Roller
- Brushes and cotton buds (Q-tips)
- Cloth, scrim or other materials to subtract ink from the matrix

PRINTING A MONOPRINT

Remove the offset image, drawing guide or plate from underneath the transparent sheet. Register the previously printed image over the transparent sheet using the guidelines already in place for the paper, then run it through the press. Don't forget to ghost-print the image (print a second print onto a clean sheet of paper by applying more pressure).

TIP AS LONG AS YOU ARE USING A REGISTRATION SYSTEM, YOU CAN PRINT INNUMERABLE TIMES OVER MONOPRINTS AND THEIR GHOSTS.

ABOVE Sarah Riley, *Marc's House*, detail. This example gives you an idea of how you can use monoprinting to enhance areas of an existing impression. In this detail, an opaque, light yellow ink was rolled on to a smooth plastic surface, worked subtractively with a cotton bud, and then printed over a darker ground.

RIGHT Kathleen Shanahan, *Amphora Akhenaton II*, detail. In this detail, note the wiping away of areas of ink to emphasise a face, looking upwards, beside the head of the Egyptian sculpture. Also note how a few wipes of the cloth indicate a hand coming from behind to grasp the shoulders of the sculptural representation. Other subtractive wipes were used to add definition and movement.

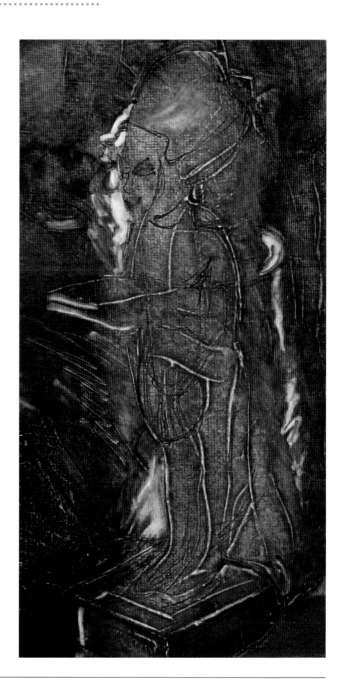

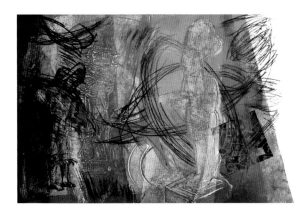

1 Kathleen Shanahan, *Amphora Akhenaton I*, 40.6 x 58.4 cm (16 x 23 in.). In this first version of the prints created using the plate in the next image, many techniques are combined, including the use of stencils and drypoint (for explanations see below, and pp.61–2 and 72–83).

3 Using a brayer to roll the plate with blue. For *Amphora Akhenaton I*, the plate was inked and wiped in the intaglio manner with greenish-gold and red; it was then relief-rolled with blue and white inks of a different viscosity.

5 The plate with its first layer for the print, after it has been rolled with blue and white inks of different viscosities. The plate was then placed on the press with a piece of prepared chine collé, glue-side up.

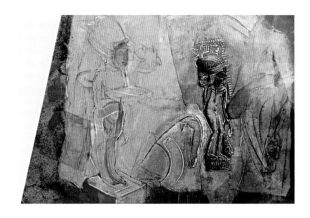

2 The mounting board plate used for the *Amphora Akhenaton* prints. This plate, also viewed on p.21, was used for a series of monoprints.

4 Mixing intaglio ink with a light (#oo) burnt copper plate oil to the consistency of double cream.

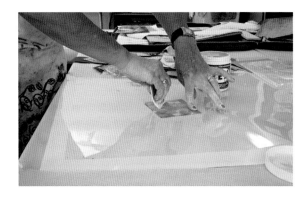

6 A piece of patterned rice paper being squeegeed with some YES paste (or a similar low water content, dextrin based adhesive; Pritt Stick may be used), a quick form of chine collé.

1 Examining the first layer of the print immediately after pulling it from the press. Note the square of chine collé at lower right.

2 A stencil was cut from newsprint. It was placed over an area of the print to block it from a second layer of ink.

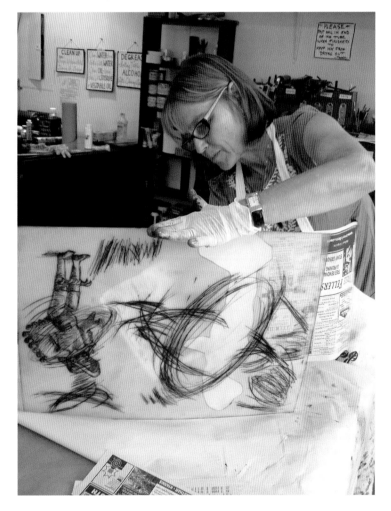

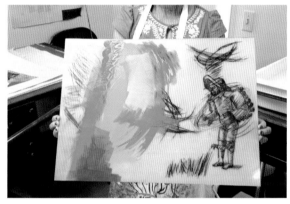

4 Additional rolls and brushstrokes of coloured inks were added, along with subtractive work done with cloth and cotton buds, to the Perspex plate on top of the drypoint.

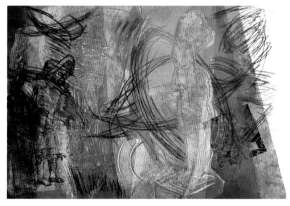

3 Kathleen Shanahan at work in the Castle Hill Printmaking Studio at Truro Center for the Arts in Massachusetts. A drypoint plate was inked and wiped with black etching ink. A final wipe is given to the edges of the plate and its back.

5 The final version of the first monoprint pulled from the ***Amphora Akhenaton*** plate.

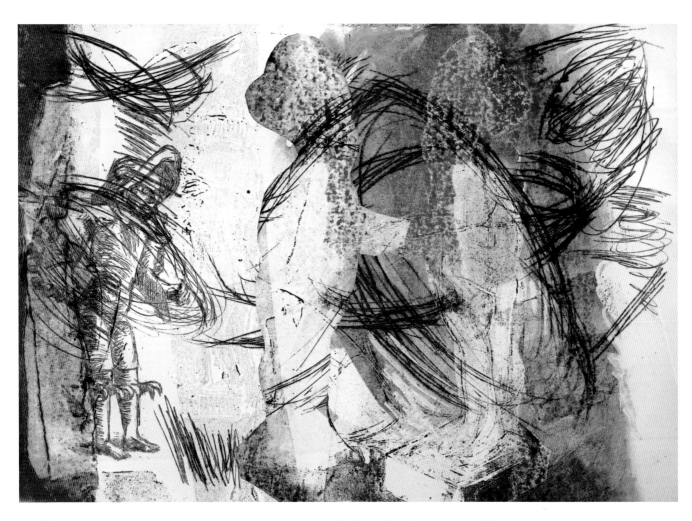

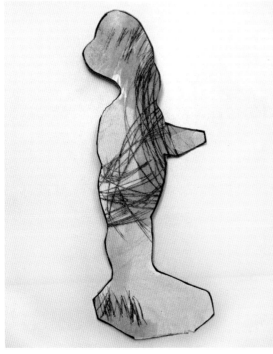

ABOVE Kathleen Shanahan, *Amphora Akhenaton I*, ghost, 40.6 x 58.4 cm (16 x 23 in.). For this ghost print, the stencil was flipped. You can see that the ink left on the stencil from its first run through the press has offset on to the ghost print beside the original figure of Akhenaton.

LEFT The *Akhenaton* stencil. After each inking and printing of the plates, a second print or ghost was pulled (using more pressure). The plates still had sufficient ink on them to create a clear ghost image. This stencil was used in both the original monoprint and its ghost.

ARTIST PROFILE

JULIA TAMAR SALINGER

Julia lives and works in New York City and Wellfleet, Massachusetts. Her approach to monoprinting is direct and immediate. Working on a slick surface, she manipulates the ink and paint until finding, through chance, a form or texture that she wants to use. She often combines the monoprinting with drawing and painting after the fact. 'The element of surprise emerges from the layers ... The saturation of information imbues the piece with a sense of age and memory. Part of my process is daydreaming or night-dreaming ... feeling like a channel or instrument by which all the sounds, sights and smells of the day are incorporated.'

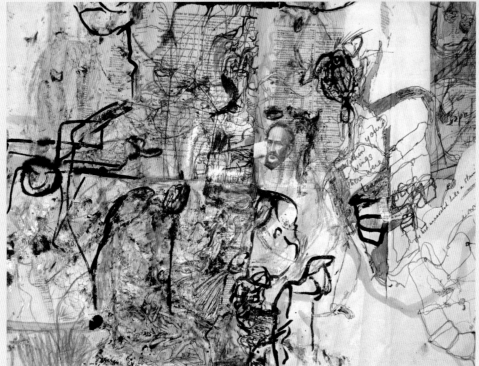

ABOVE Julia Tamar Salinger, *After the Fall*, 55.9 x 81.3 cm (22 x 32 in.). Salinger's prints are like knots of expressionistic colour and gesture. This one includes the techniques of woodcut, drawing transfer from Perspex (monotype and trace montype) and gel transfer.

LEFT Julia Tamar Salinger, *When We Meet Again We Will Be Tattoos*, 50.8 x 101.6 cm (20 x 40 in.). Monoprint, woodcut, ink on Perspex, collage.

ARTIST PROFILE

DAVID ELLIS

David is currently based in Provincetown, Massachusetts. He is a photographer, multimedia artist and printmaker, and reflects that: 'It is interesting how my background in 2D work and printmaking influence the work in video, especially in colour choices and composition.' He says, of this series of monotypes, that: '[They] were produced initially as an exploration into the incorporation of "vernacular" or anonymous photographs into works created using a monotype/intaglio or relief printing process ... I began by thinking about how we value "art" by knowing the author, and tend to be dismissive of "unknown" authors or value the work by "how important" the artist/author is or was. With the introduction of the box camera to the public, there was almost immediately a new opportunity for anyone to be creative, to produce artistic compositions or capture moments depicting events or subjects with a personal touch ... I decided to pick some of these images and incorporate them into my prints, giving the discarded photos [a] "new" significant moment, a new purpose as they became part of a new image with a new intention.'

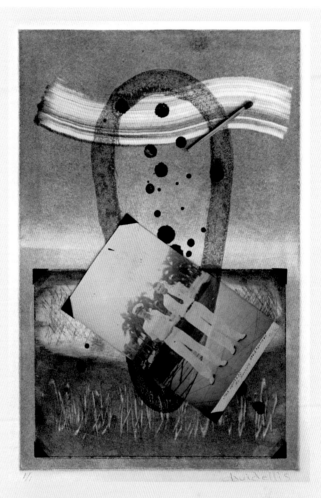

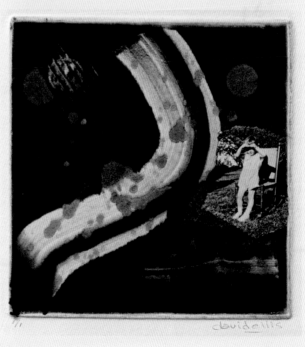

Top David Ellis, *Sailors*, 15.2 x 22.9 cm (6 x 9 in.). 'I wanted to either interpret the feeling or perceived story through lines and textures and tones that would relate to those in the photographs, along with the flow of the image, if we were to see what had extended beyond it.'

Bottom David Ellis, *Cosmic Moment*, 17.8 x 17.8 cm (7 x 7 in.). 'Perhaps from my own childhood moment, when I was touched by an experience of light and grace!' Inks were manipulated on a non-porous matrix with cards and brushes before printing.

ARTIST PROFILE

VERNITA NEMEC

Based in New York City, artist, activist, performance artist and curator Vernita Nemec produces work in a variety of media. Recent performance pieces have been enacted in France and Japan. Her art is made from what others discard. The detritus of the cast-off beach dress transforms into an evening dress and becomes the matrix for a monoprint when it is pressed into inks and then offset on to paper using an etching press. The addition of other found imagery in Beachdress contributes to its 'resurrected', otherworldly quality.

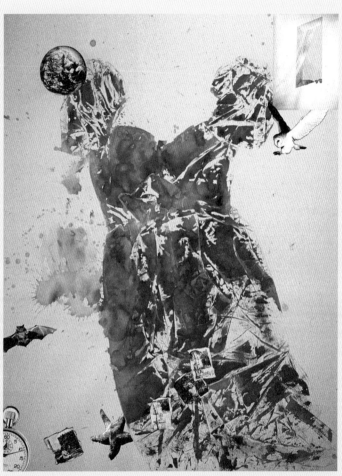

Above Vernita Nemec, ***Beachdress***, 119.4 x 96.5 cm (47 x 38 in.).

Left Vernita Nemec, ***Missing in Action***, 35.6 x 27.9 cm (14 x 11 in.). Ferns pressed into ink, as well as collage, were used to create this monotype.

WATERCOLOUR MONOPRINTS

Both Dura-Lar and Yupo (see box) may be used as a substrate on to which you may paint a watercolour image over a base of dried gum arabic. Any water-based, non-permanent paint such as watercolour or gouache will work for this technique.

Apply a small amount of gum arabic to the substrate and buff to a dry finish with cheesecloth before painting on the watercolour. Allow the painting to dry before running it through the press on to soaked and blotted printing paper. The dried gum arabic will help the image transfer from the plastic surface to the paper.

With Yupo, it is also possible to transfer the image to the paper without first preparing the surface with gum arabic, but you must work quickly and print the image immediately after it has dried. The longer you wait, the paler the image will be when you print it. The use of gum arabic definitely contributes to the release of a greater amount of the watercolour from the surface of the Yupo.

TIP WASHING-UP LIQUID MAY BE USED AS A SUBSTITUTE FOR GUM ARABIC IN PREPARING A NON-ABSORBENT SURFACE TO ACCEPT AND TO RELEASE THE WATERCOLOUR FOR THIS TYPE OF MONOPRINT.

Yupo and Dura-Lar

Dura-Lar polyester film is clear and has been treated on both sides to accept paint without beading or crawling. It is archival in quality and does not yellow over time.

Yupo is a durable plastic film made from pellets of polypropylene. It has a surface texture on which watercolour and ink washes dry in a similar fashion to the way they dry on sized watercolour paper; however, Yupo is not as absorbent. If you paint layers of watercolour, it is easier to disturb what is underneath than it would be on regular watercolour paper, but you can achieve many of the same desirable qualities of watercolour painting on Yupo. It is smooth, pH-neutral, has a bright white surface, and is recyclable.

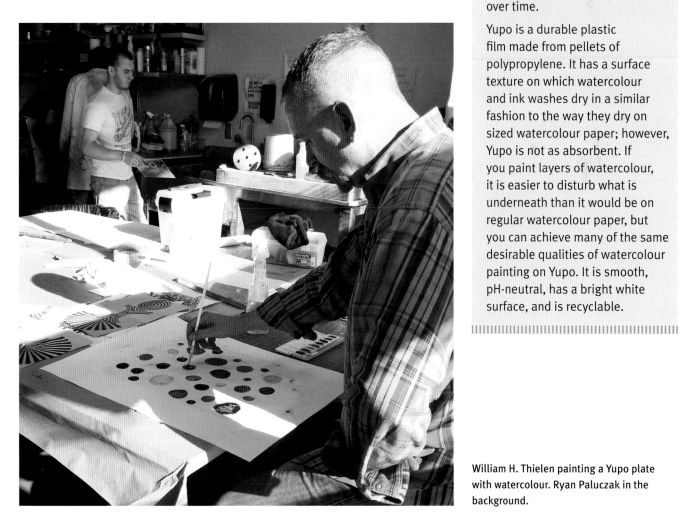

William H. Thielen painting a Yupo plate with watercolour. Ryan Paluczak in the background.

Above In the studio, prints in process.

Above Bill Thielen achieved this soft monotype effect by using small drops of permanent Indian ink on Yupo that had previously been buffed with gum arabic. Damp Arches Cover paper was placed over the still-wet acrylic inks and run through the press. When using this method, put plenty of newsprint covering sheets over everything, as well as protective plastic sheeting (to catch any ink spread). This will safeguard the expensive press felts. You may also prefer to just replace the felts with old blankets when using this method of monotype.

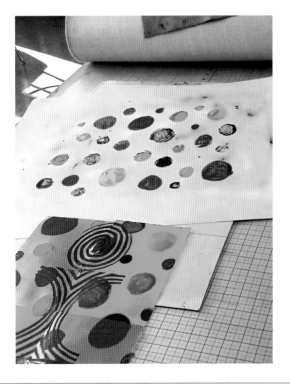

Left William H. Thielen, *Untitled*, 27.9 x 38.1 cm (11 x 15 in.). The print and plate on the press after printing the watercolour layer from the Yupo plate. The previous layers are watercolour painted directly, and the black shapes are from a carved linoleum plate printed in relief.

R<small>IGHT</small> William H. Thielen, *Untitled*,
27.9 x 38.1 cm (11 x 15 in.). Two drypoint
plates were printed many times with
black ink, and at different angles, over the
previous monotype.

B<small>ELOW</small> Sarah Riley, The Yupo plate with
watercolour used for *Full Moon II* (overleaf).

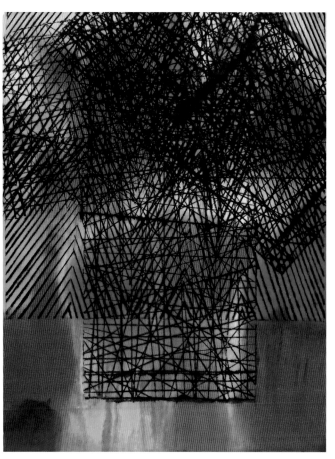

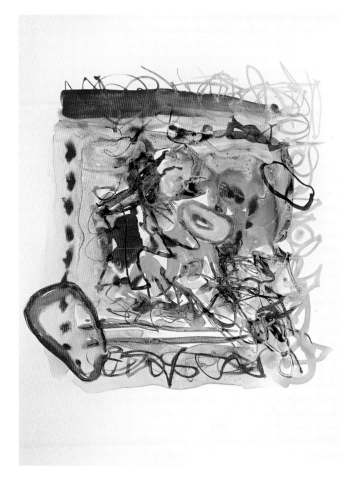

TIP Y<small>OU CAN ALSO USE</small>
D<small>URA</small>-L<small>AR FILM, WHICH HAS THE</small>
<small>ADVANTAGE OF BEING A CLEAR</small>
<small>SUBSTRATE, FOR WATERCOLOUR</small>
<small>MONOTYPES.</small> M<small>ANY NON-POROUS</small>
<small>SURFACES MAY ALSO BE USED.</small> B<small>UFF</small>
<small>THE SURFACE WITH GUM ARABIC</small>
<small>BEFORE APPLYING WATERCOLOUR.</small>
T<small>HE GUM ARABIC MAKES THE</small>
<small>SURFACE RECEPTIVE TO THE</small>
<small>WATERCOLOUR WITHOUT CAUSING</small>
<small>BEADING.</small>

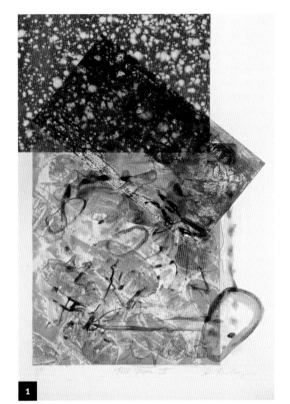

1

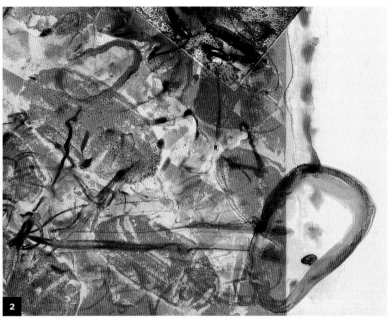

2

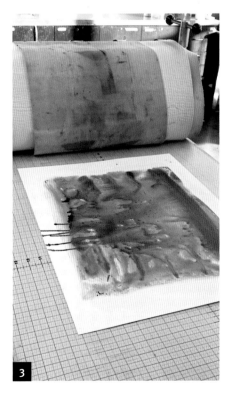

3

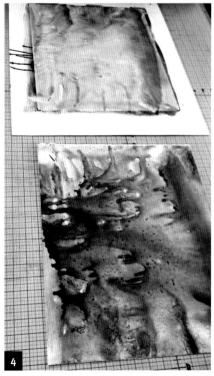

4

1 Sarah Riley, ***Full Moon II***, 38.1 x 55.9 cm (15 x 22 in.). In this image, Sarah transferred a watercolour image from Yupo to printing paper prior to printing over it with two shaped collagraph plates and a piece of chine collé.

2 Detail of ***Full Moon II***. In this detail of the layered print, you can see the delicate washes of yellow, red and blue to the right of the print and under the pink collagraph plate.

3 Some loose watercolour washes on Yupo. The plate is dry and on the press just prior to printing. It will be used as a background layer for a polyester plate litho.

4 The plate and print on the press just after printing.

TRACE MONOTYPES

A trace monotype is a way of offsetting ink directly from an inked matrix by placing the printing paper directly over it. Draw directly on or rub the back of the print paper to produce line and tone. First, roll out a film of thin ink on a piece of glass or Perspex (or use a sheet of plastic such as Mylar). Place a piece of paper over the ink film. Draw on the paper (or actually what will become the reverse side of the print) with a pencil, pen, or end of a brush, etc. (To protect the back of the print, you may want to add another sheet of paper such as newsprint before drawing.) Gently rub the paper to transfer some tone as well. Wherever you press on the paper, ink will transfer. (If you have rolled the ink on a Perspex plate or a sheet of Mylar, it may then also be printed on the press as a negative of the original.)

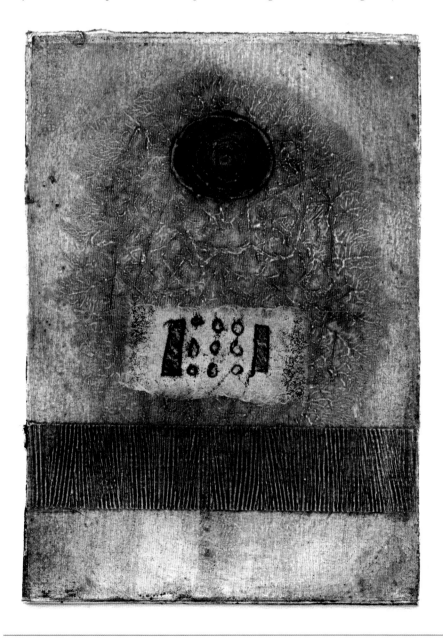

Joan Hausrath, *Egypt 2*, 12.7 x 17.8 cm (5 x 7 in.). Note the lighter rectangle of chine collé. This is a trace monotype on rice paper. Joan used two pieces of mounting board for her base plates; she coated them with gloss medium first. Plate one has a texture made from gesso in the centre. For plate two, she applied gesso horizontally over a mask created with tape. She then scraped through the horizontal band of gesso with a plastic serrated knife to give it a striated texture. The circle was made with gesso and then it was scratched into after it had dried, creating some fine lines that would print as a darker value.

She made the print from the two plates and there were two runs through the press. With plate one, she inked the background with an orange – some blue ink was wiped in around the edges of the plate before printing. The black bar and circle were inked and printed from plate two. The chine collé rectangle (trace monotype) was adhered at the time of the printing of plate two.

ARTIST PROFILE

JOAN HAUSRATH

Joan Hausrath, university educator and member of the Rhode Island Printmakers' group, Nineteen on Paper, works in layered printmaking. The works pictured here are made of three to five printings from different plates. She used mounting board for the base plates, coating it with acrylic gloss medium before adding textures.

She likes to add collaged papers, cloth, drawings with Elmer's glue (craft glue), and textures created from stucco gel. Joan draws into wet gesso on some of her plates, and in others uses gesso as a base for drypoint after it has dried. As she says, 'I like making a bunch of plates and then printing them in various combinations.' She incorporates trace monotypes made on rice paper as chine collé. She derives inspiration from drawings made during her travels, and sketches from ancient architecture and hieroglyphs. The prints become a secret language of long-lost memories.

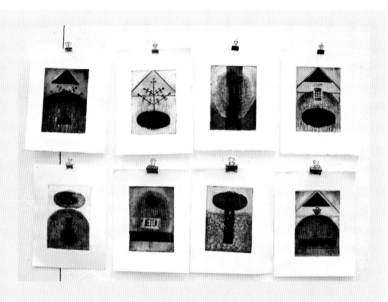

Top Joan Hausrath's prints drying in the studio.

Bottom Joan Hausrath, *Egypt 1*, 12.7 x 17.8 cm (5 x 7 in.). 'Two plates were made on mat (mounting) board bases. Plate one had squiggly lines made with Elmer's (craft glue) at the bottom and the oval made of scrim (tarlatan) at the top. The piece of scrim had gloss medium applied on top of it. Actually, the oval was a ghost because the first printing of it was too inky – scrim holds a lot of ink. I inked and printed the top and the bottom of the plate separately. Second plate: the vertical line was made with acrylic stucco medium. There were three printings: 1. Purple inked in swirly area – I wiped most of the ink away. Then I rolled over it with a low-viscosity ochre. 2. Red-orange oval – inked and wiped as an intaglio before printing. 3. Black vertical – printed from second plate.' When printing only parts of a plate, Joan uses newsprint, like a stencil, to mask the rest of the plate.

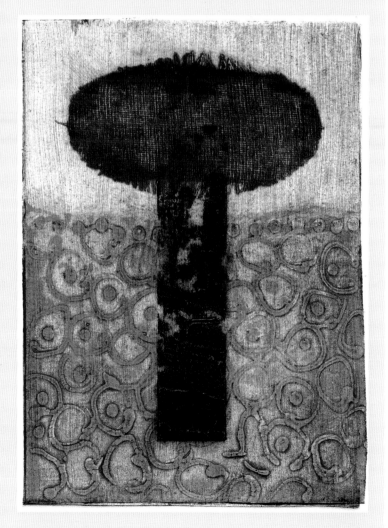

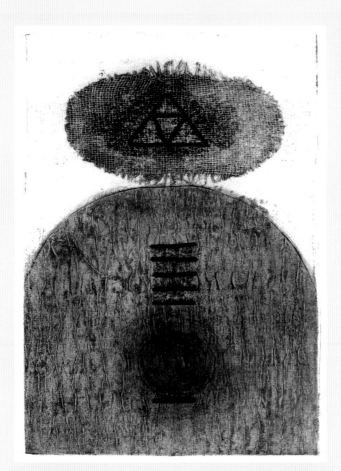

Joan Hausrath, *Egypt 3*, 12.7 x 17.8 cm
(5 x 7 in.). Four printings from parts of three
plates. The big curved area was made with
textured paper. The circle was printed from
a plate used in *Egypt 2* mentioned above.
The brown marks were made with the trace
monotype technique.

Joan Hausrath, *Egypt 4*, 12.7 x 17.8 cm
(5 x 7 in.). 'Four printings from parts of four
plates. The large blue triangle was thin
cardboard (cereal box) adhered to a plate
and wiped as an intaglio. Two other plates,
mentioned above, were used. The brown
lines were created from a thin, foam-core
plate coated with gloss medium. Then, using
a ballpoint pen, I pressed lines into it and
inked and printed it as an intaglio.'

3 Chine collé, stencils and rainbow rolls

CHINE COLLÉ

THE TERM 'CHINE COLLÉ' comes from the French words meaning 'Chinese' and 'glued', the 'chine' referring to thin papers imported from China and Japan. 'Chine collé' is used to denote a technique for gluing shapes or sheets of rice paper or other thin paper on to a print with a press. Use it to add colour, texture and shapes – both subtle and bold – to mixed-media prints.

ABOVE **Choosing and cutting shapes for chine collé from rice paper and handmade papers.**

RIGHT **Materials for preparing chine collé: spray bottle of water, rice paste powder in a shaker, pieces of rice paper.**

YOU WILL NEED

MATERIALS

- Rice paper or other thin paper (these may be dyed and dried first using permanent inks or acrylics)
- Powdered glue: wheat or rice paste powder (alternatively, use a dextrin-based adhesive with a low water content or a Pritt glue stick)

TOOLS

- Spray bottle
- Shaker or an old sock for glue powder

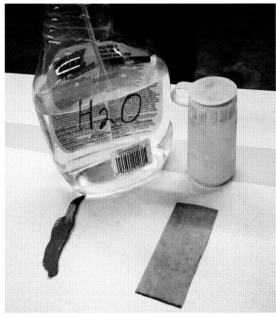

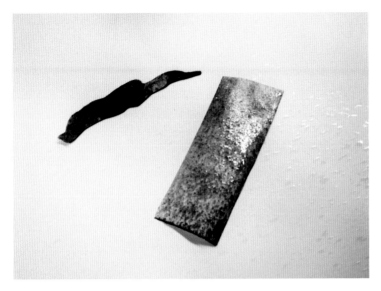

USING CHINE COLLÉ

1. Spritz water on the back of the rice paper to be glued to the print. You should not be able to see a glossy film of water on the surface. Blot excess water before applying the powdered glue.

2. Shake the glue powder over the back. (If using another adhesive, simply scrape some of it on the back of the rice paper with a small squeegee or an old credit card.)

3. Lightly shake off any excess powder before placing the piece of rice paper on the previously inked plate. The glue side should face upwards and away from the inked plate.

4. Cover everything with the printing paper, then a sheet of clean newsprint. Run through the press.

ABOVE **Spray the rice paper.**

Blot excess water. The paper should be evenly damp, but not wet and shiny.

RIGHT **Shake rice paste powder evenly on to the surface of the damp paper.**

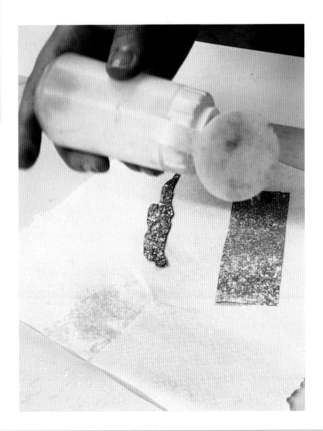

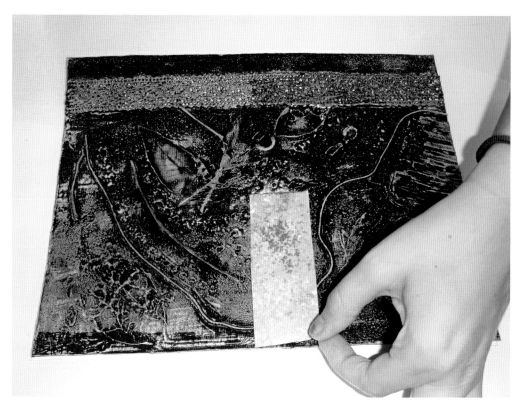

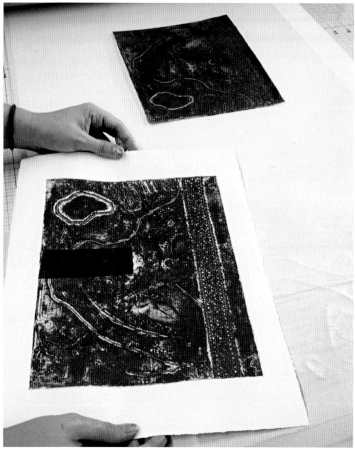

Above Shake off any excess glue powder before placing the shape, glue-side up, on the inked and wiped printing plate. Cover with the dampened printing paper, then a sheet of clean newsprint, and crank through the press.

Left Jessica Espinoza examining her proof.

ARTIST PROFILE

SARAH RILEY

I was a student of Norman Ackroyd's in Richmond, Virginia at Virginia Commonwealth University (then Richmond Professional Institute), many years ago when he was a visiting professor of printmaking from the UK. His acute observations and critiquing skills were formative in my own printmaking education. His work in the 1960s had a strong pop art influence and he taught us his technique for transferring newspaper images to zinc plates. He gradually moved away from pop art towards abstraction, and eventually to the landscape etchings (highly experimental in technique) for which he is known today. In 1990 he was elected a member of London's Royal Society of Painter-Printmakers. His work reflects the landscape (and sometimes the architectural exteriors and interiors) from his travels throughout the British Isles, and conveys the amazing orchestration of the light and mist of northern landscapes. He is a master of etching techniques such as sugar-lift and aquatint, explanations of which are in *Printmaker's Secrets* by Anthony Dyson, published by A & C Black in 2009. Norman's work is represented in the collections of major museums including the Tate and the British Museum, and in the USA, the National Gallery of Art, Washington, DC and the Museum of Modern Art, New York.

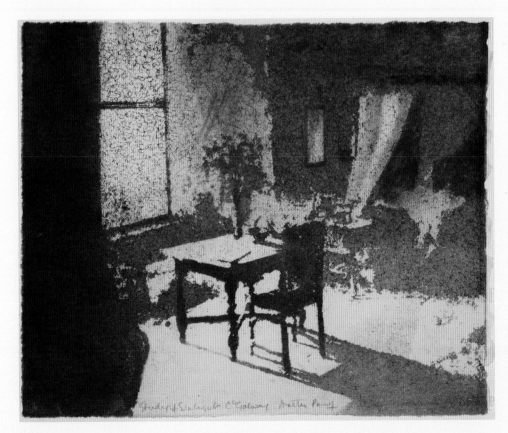

Norman Ackroyd, *Study of Sunlight, Co. Galway* (Archive Reference number: 521), etching, chine collé, 19.5 x 23.5 cm (7⅝ x 9¼ in.). This drama of light and shadow takes place in Oranmore Castle in the county of Galway, Ireland. The mysterious play of light and shadow was created on a metal plate with sugar-lift and aquatint techniques. It was printed on a thin piece of handmade Japanese paper (note the deckle playing out on the right-hand edge of the image), giving it a warm and delicate air. The print in turn was glued, via an etching press, to a piece of printmaking paper in the manner of chine collé.

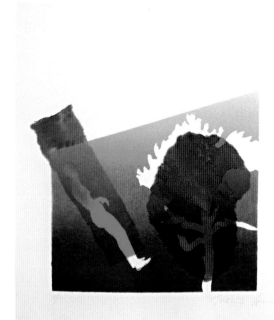

Sarah Riley, *Marc's House I*, 38.1 x 55.9 cm (15 x 22 in.). This print incorporates a rainbow roll, monotype, stencil and chine collé. The chine collé was made from torn pieces of hand-stained rice paper. The rice paper was stained with permanent Indian ink and allowed to dry before being used in the chine collé process. The pieces of chine collé can be seen to the left as the diagonal rectangle of dark green, in the middle as the red lung shape, and to the right as the dark blue and green rectangles.

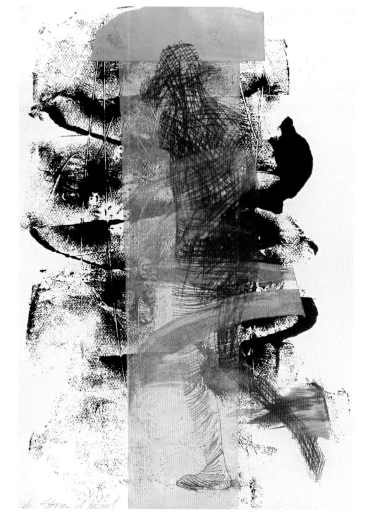

Sarah Riley, *Storm of Arzanol*, 38.1 x 55.9 cm (15 x 22 in.). For this print, black acrylic paint was rolled out on plastic sheeting with a sponge roller. Working quickly with the wooden end of a brush, additional lines were subtracted from the quick manipulation of paint. Rough watercolour paper was then pressed on to the plastic sheeting to create the basic monoprinted image that this print was built upon. Once the black paint was dry, the paper was soaked in water for an hour to soften its sizing. Then a drypoint plate of the figure in red was printed, along with some monoprinting done with gold and green ink using a discarded credit card, on to the same plate. At the same time that the drypoint plate was printed, hand-stained rice papers (the yellow and green central shapes of colour) were added to the print as chine collé.

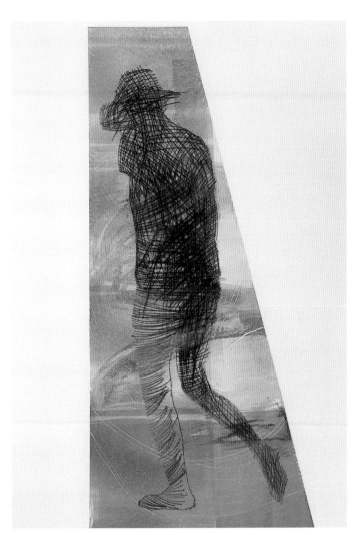

Sarah Riley, ***Storm of Arzanol II***, 38.1 x 55.9 cm (15 x 22 in.). This is the ghost print of the previous image. On top of the red drypoint image with the remnants of the strokes of green and gold ink from the first printing, a lavender ink of a different viscosity was rolled directly on to the plate using a 15 cm (6 in.) soft Speedball brayer. Lines were then subtracted from the plate with the wooden end of a brush. Though collagraph plates can usually be printed two or three times, giving clear ghost prints, the same is not usually true of etchings or drypoints. The difference, in this case, was the large amount of sizing in the watercolour paper used for the first printing. Because of its harder quality, the paper did not absorb as much ink from the drypoint as it normally would. By setting the press to a higher pressure as well as using a softer paper, Rives BFK, for the second printing, the plate was able to yield a clear ghost image.

STENCILS

The use of stencils as masks is a good way to block parts of an image from printing. The stencil may then be reversed and printed (offset/counterproofed). Stencils may be used extensively in other ways as well.

USING STENCILS

YOU WILL NEED

MATERIALS

◆ Thin plastic such as Mylar or polyester (does not stretch), or newsprint

TOOLS

◆ Scalpel or matknife

◆ Brayer or roller

1. Cut stencils from the plastic or newsprint, place these strategically on your intaglio-wiped plate and, using a brayer or roller, roll ink over the stencil. Remove the stencil before printing.

2. Stencils may also be used for masking areas of a plate, preventing the covered portion from printing on the printmaking paper. Peel the stencil off the print after printing to reveal what is underneath – either the blank paper or colours from a previously printed layer.

3. Take the previously printed and removed stencil and transfer the ink captured on it to another sheet of paper via the press. Doing this immediately after removing the stencil from the first print will yield a good offset or counterproofed print. I first saw this technique skilfully demonstrated by the printmaker Cyndi Wish using simple newsprint stencils during a workshop at Southeast Missouri State University. You will see her work later in this chapter.

RAINBOW ROLL WITH STENCILS AND CHINE COLLÉ

The term rainbow roll (split fountain) refers to a process by which two or more colours of printing ink are simultaneously rolled onto a flat non-porous or relief surface until they are softly blended. This surface is then transferred to printing paper via the press.

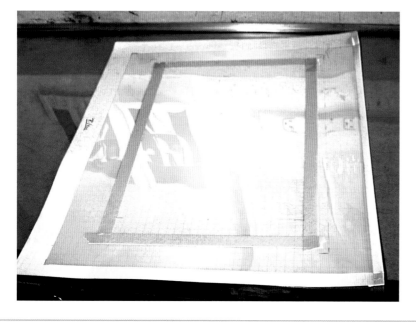

ABOVE Laying out blue and yellow etching inks for blending together into a rainbow roll. Starting with a strip of blue and one of yellow, I work the colours together with the roller. Moving the roller just slightly from left to right with each roll brings the colours closer together, until finally they are blended smoothly into a rainbow roll.

LEFT The print registration package itself can become the matrix for a monotype in oil or watercolour. For this demonstration, I first mask off the top Dura-Lar sheet of the print registration package to prepare a specific area to receive a rainbow roll of etching ink for the background of the print.

1 The prepared rainbow roll.

2 Having prepared the rainbow roll, I proceed to roll it on to the print package and over the edges of the taped rectangle. I carefully remove the masking tape after the ink has been rolled on to the matrix. Then I lay down the previously prepared stencils. I have used these same stencils for three years to demonstrate how thin, yet durable, newsprint stencils can be. Note that the Mylar figure stencil is beginning to wear out, but that the tree stencil cut from newsprint still has very clean and accurate edges.

TIP NEWSPRINT STENCILS CAN BE USED ALMOST INDEFINITELY. THEY ABSORB THE ETCHING INKS OVER TIME AND BECOME STURDIER.

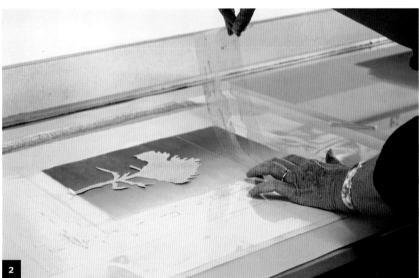

3 Pieces of paper are torn, prepared and placed for the chine collé process. After laying dampened printing paper on top of the print package of rolled ink, stencils and chine collé (glue-side up, facing the printing paper), everything is cranked through the press.

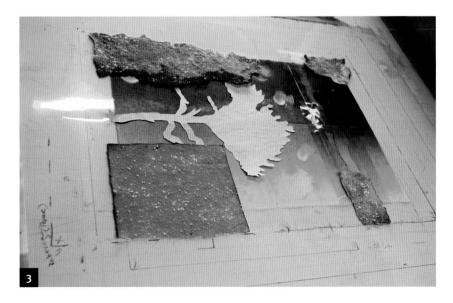

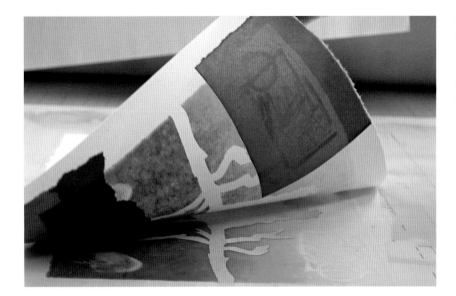

Checking the print by lifting the end slightly to see if the pressure should be more tightly adjusted for a second roll through the press. If necessary, tighten the press and roll it through again. If it looks good, take it off the print registration package at this time to examine it and to prepare for the printing of the ghost.

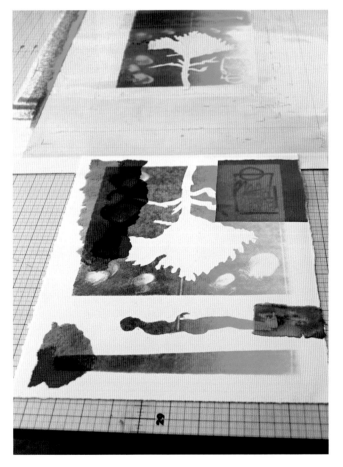

Examining the print.

Removing and flipping the stencils in order to make a ghost print.

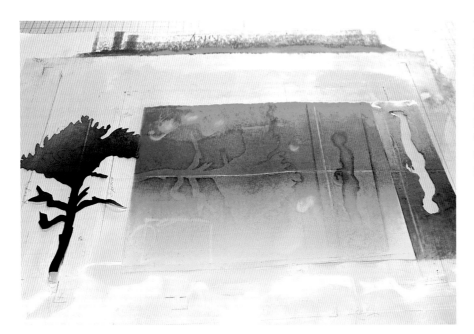

The tree and figure stencils are flipped and placed in a trial arrangement on the print package. The stencils, which prevented the ink from printing on to parts of the previous print, are now positioned face-up. They will offset the ink pressed on them from the previous run through the press on to a fresh sheet of dampened printing paper. Note the ghostly edges of the stencils from their first position on the print package.

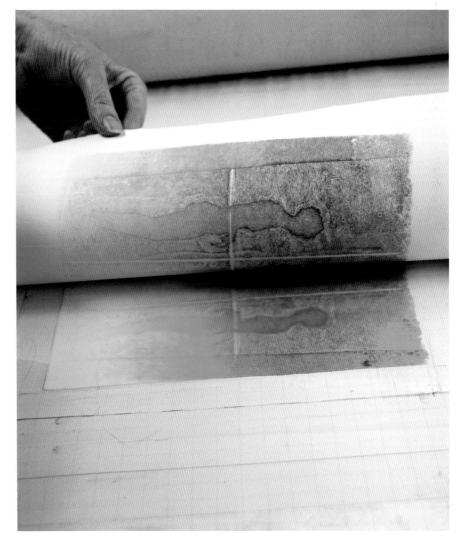

After the stencils have been adjusted to their final positions, the print is rolled through the press. One end of the paper is left caught under the roller so that the other end can be lifted slightly to check the image. Deciding that the image is too pale, the paper is lowered back into place. The pressure of the press is tightened and the print goes through the press again.

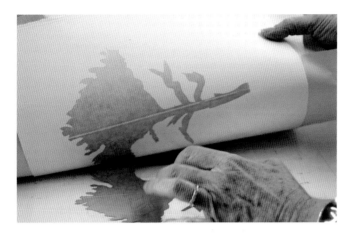

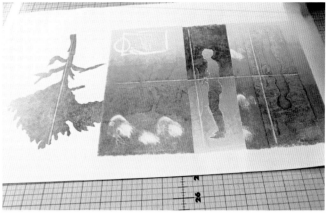

Separating the ghost print from the stencil after printing.

Examining the ghost print. Further layers can be added at this point.

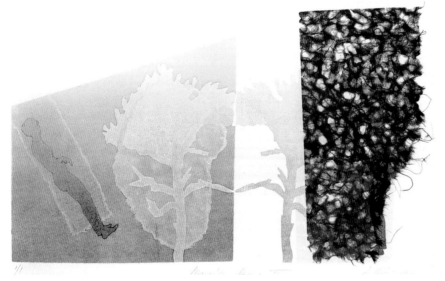

Sarah Riley, *Marc's House II*, 38.1 x 55.9 cm (15 x 22 in.). A ghost image printed from the ink remaining on the sheet of plastic used as the matrix for *Marc's House I* (see above), with the stencils reversed and offset or counterproofed. A lacy rice paper was used for the chine collé.

Liz Coffey, *Disentanglement*, 15.2 x 30.5 cm (6 x 12 in.). In this print, a stencil shape suggesting crossed legs was placed over a yellow collagraph print. A second printing from a plate inked in brown tones retains the image of the entangled legs in yellow. The stencil was used as a mask to protect the yellow colour beneath. The metallic puzzle forms were then printed from a copper intaglio plate.

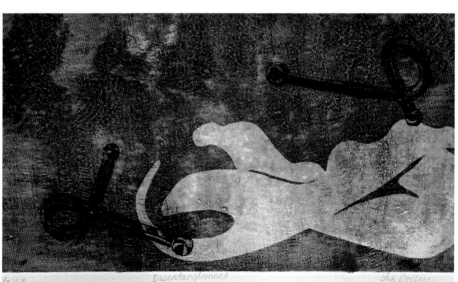

LEFT Nathan Kohm, *To Speak of Hell*, 27.9 x 35.6 cm (11 x 14 in.). Starting with a strip of red ink and one of yellow ink, Nathan worked these colours with the roller, gradually moving them closer together as he rolled them for a rainbow roll. He had previously taped off a sheet of Dura-Lar with masking tape to achieve the overall rectangular size of the print and then transferred the rainbow roll on to it using a large roller. Then he removed the tape so that he would have a clean edge to the image area. Stencils of an explosion and a hand with a lighter were cut earlier from newsprint. The stencils were placed over the rectangle of blended red and yellow inks. He placed chine collé pieces on top of the stencils, then covered everything with dampened printing paper and rolled it through the press.

ABOVE Nathan Kohm, *To Speak of Hell* (ghost), 27.9 x 35.6 cm (11 x 14 in.). For the ghost print, Nathan removed the stencils from the Dura-Lar sheet and used a cotton bud to draw into the ink, creating the face and the lines around the explosion. He then ran it through the press on to another sheet of dampened printing paper at a higher pressure.

ABOVE Matt Puzzella, *Diablo* (ghost), 27.9 x 35.6 cm (11 x 14 in.). In his second pull or ghost print, Matt experiments with symmetrical and nearly symmetrical shapes. The darkest red shape is chine collé.

ARTIST PROFILE

CYNDI WISH

Cyndi Wish was in graduate school at the University of Sydney in Australia when one of her instructors asked her if her way of making prints was particularly American: 'You know, that dramatic over-inking that you do, the uneven press pressure, the combining of rubber and water-based inks? All that bleeding; crinkling paper?' She took a moment, she says, 'to think about the internship I did at the Rutgers Center for Innovative Printmaking, where I learned about tight editioning, and then to think about the kids I worked with in Trenton who made me consider that a printmaking matrix could be almost thought of as a brush, or a palette knife, or a sculpture tool. It makes me and my way of working a liability in a standard print shop, but I like the kids' approach better.'

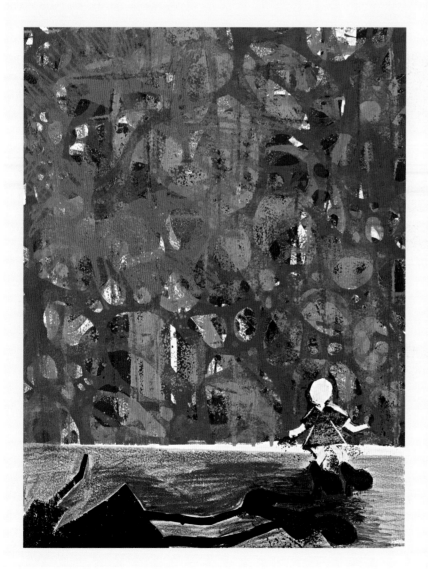

Cyndi Wish, *Shadow*, 55.9 x 76.2 cm (22 x 30 in.). For this print, Cyndi combines several techniques with stencils. 'The first marks made on the paper are rectangular forms made from monoprinting grey tones through paper stencils on the top three-quarters of the composition. The arrangement of these shapes represents a cityscape. The city is then obscured by fog and the night sky, which are indicated by prints from two woodblocks: one with a series of positive and one with a series of negative amorphous circular forms. In much of my work from this period, those forms appear as a happy virus that swallows things before it. While printing these layers, a stencil of the little figure form was affixed to the paper, to hold the spot in the composition. The shoes and the dress on the figure are monoprinted through a template, as is the stalker who follows the little figure. The ghost of an orange dress, which appears in the night sky, is a scribbled trace monotype around a dress-shaped stencil. Graphite, applied directly to the paper, adds depth to the sidewalk around the feet of the girl and her stalker.'

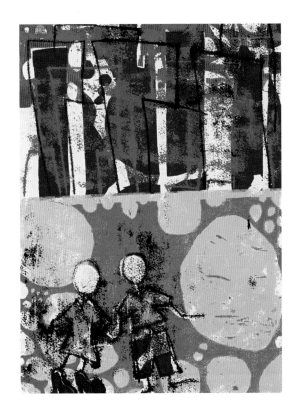

Cyndi Wish, *City Walk*, 27.9 x 35.6 cm
(11 x 14 in.). A monoprint using trace
monotype, stencilling and woodcut.

William H. Thielen, *Bits and Pieces*,
38.1 x 48.3 cm (15 x 19 in.). In this
monotype, a black and white rainbow roll
is used in the background. Stencils were
used both as masks and as offsets. The
small white dots to the left were relief-
printed over a collagraph. Finally, collage
and hand-drawing were added.

ARTIST PROFILE

UTE HARING

Ute Haring was born in Leipzig, studied art in the UK at Wimbledon School of Art and now lives in both London and Leipzig. The PRESSESCHAU-series was made during a residency at the Sir William Perkins School, London, in 2006.

Ute comments: 'For the drypoints, I used zinc plates to give me the option of burnishing, although I did not use [this] very much in the end. The linocuts were printed on a yellow Chinese paper. Although I work with etching quite a lot, I like the drypoint and linocut/woodcut techniques for the direct energy that goes into establishing the image on a hard surface.

'In the PRESSESCHAU-series I am concerned with the overlapping and merging of different spaces and the shifts in context that occur in our world today because of the constant exposure to all kinds of images via various media. The combination of the techniques, with their distinct characteristics, and the process of collage (chine collé) seemed to me an appropriate way to explore this idea. The inspirations for the series [were] newspaper photos and my own photos. "PRESSESCHAU" is a German term and is the title of a TV programme in which news stories and events are discussed and analysed. To me, this term also describes well the process of flicking through a newspaper or watching news stories on [the] TV/Internet and thus being exposed to a flood of images, a lot of which are quite disturbing. These images enter our lives, our private space, and leave a lasting impression.'

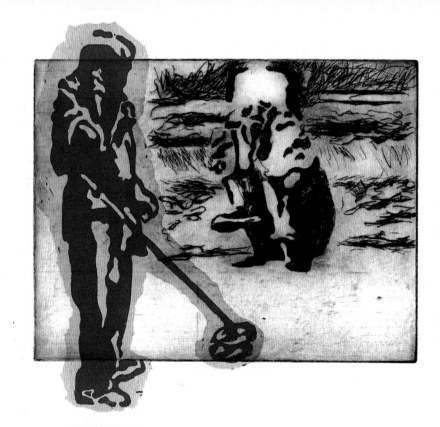

Ute Haring, *PRESSESCHAU-series 1*, drypoint, chine collé with linocut, 15 x 20 cm (6 x 8 in.). Ute used a zinc plate as the matrix for his drypoint imagery. The preparation of a zinc plate is the same as for a copper plate (see pp.77–8). Linocuts were printed on yellow Chinese paper. These images were then glued to the print paper at the same time as the drypoint plates were printed.

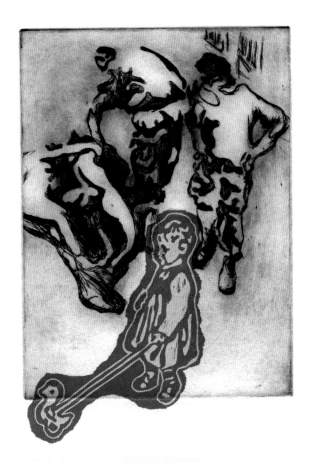

LEFT Ute Haring, ***PRESSESCHAU-series 2***, drypoint, chine collé with linocut, 15 x 20 cm (6 x 8 in.). Sometimes uncanny and surreal parallels emerge from Ute's reworking of images from the constant media barrage of the endless unfolding of horrific wars; he juxtaposes these with fragments of non-televised images from everyday life.

BELOW Ute Haring, ***PRESSESCHAU-series 4***, drypoint, chine collé with linocut, 15 x 20 cm (6 x 8 in.).

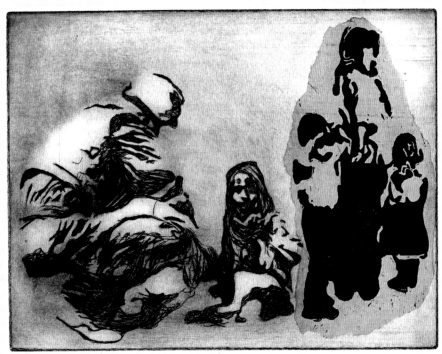

4 Drypoint

DRYPOINT IS AN INTAGLIO TECHNIQUE where a sharp tip is used to scratch marks on a plate. The line created with drypoint is softer than that of a line etched into a metal plate with acid or ferric chloride, because the metal surface is not being eaten away. Instead, you are scratching into the surface and raising a burr of the material that you are displacing. This burr surrounds the marks that you make, holding ink and softening their appearance. Intaglio involves the inking and printing of the areas 'cut into' a plate, whether the marks have been drawn by hand or etched with acid.

TIP DRYPOINT CAN BE DONE ON ALMOST ANY HARD, FLAT SURFACE TO CREATE LINES AND AREAS OF VALUE FOR A PRINT.

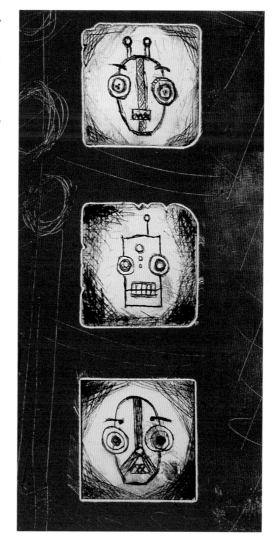

Andrew Arth, *Three Tinks*, 17.8 x 27.9 cm (7 x 11 in.). This simple print, with a monotype background (brayer rolls of red ink on top of a cardboard plate, marked into with the end of a brush), involves three small Perspex drypoint plates dropped into place on top of the monotype before printing. It is an example of how simplicity can convey intimacy and the artist's hand with the most inexpensive of materials.

Compare the difference in marks made by an etching needle or other sharp point with those made by carving into linoleum or wood, or those made by etching. Try working a variety of surfaces with a sharp tool, sharpened nail or etching needle. Surfaces to use for drypoint include metal plates (especially copper), Perspex plates, or mounting board painted with gesso or acrylic medium. At the beginning of the book you saw some prints by Kathleen Shanahan in which the mounting board matrix had been drawn into with a scalpel blade and an etching needle. To do this, prepare the cardboard surface as you would for a collagraph (see pp.15–16) and allow it to dry before drawing into it with the sharp tool.

BELOW Norm Hahn, ***Interweaving Iconographs***, 27.9 x 35.6 cm (11 x 14 in.). For this print, Norm inked a base collagraph plate of cardboard and acrylic medium with a mauve colour. He then relief-rolled it with a yellow etching ink of a different viscosity. Over this first printing of the collagraph, he printed a traditional copper etching of a figure. The final Perspex drypoint plate, inked and intaglio-wiped with turquoise ink, was printed last. The toned areas of the Perspex plate were created with multiple tiny scratches and cross-hatchings.

YOU WILL NEED

MATERIALS

◆ Copperplate, Perspex (Plexiglas) plate or cardboard plate sealed with acrylic medium or gesso

◆ Etching ink

TOOLS

◆ Etching needle or other sharp-tipped tool

◆ Metal file

◆ Fine sandpaper

◆ Burnisher and scraper tools for copper

◆ De-burring tool for copper

◆ Sharpening stone and oil for sharpening an etching needle or scraper tool

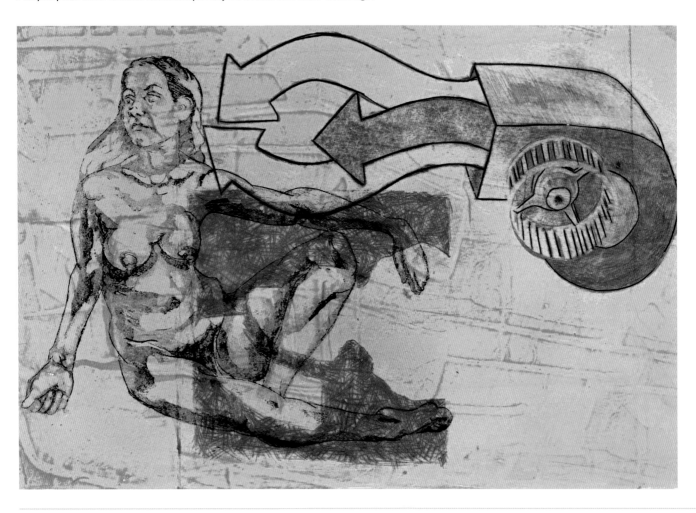

ARTIST PROFILE

EDUARDO GUERRA HERNANDEZ

Eduardo was born in 1967 in Pinar del Rio, Cuba. His art studies began at the age of 12 at the Escuela Vocacional de Arte Raul Sanchez in Pinar del Rio. He attended the Escuela Nacional de Artes Plásticas in Havana from 1982–86. After completing the five-year programme at the Instituto Superior de Arte, he graduated in 1995. He has exhibited widely, with solo shows in France, Spain and Cuba, and group shows in the USA, Portugal, Sweden, Mexico and Latin America.

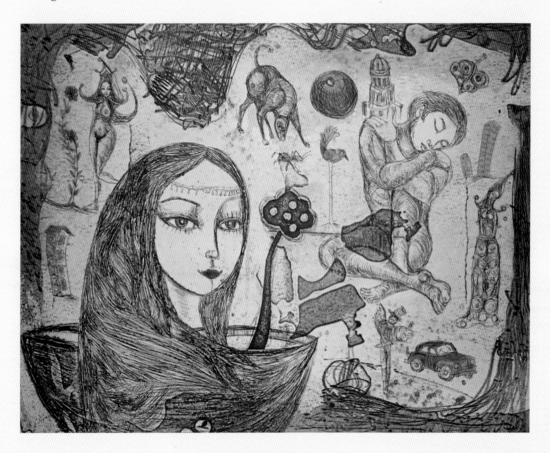

Eduardo Guerra Hernandez, *Travesia*. Collagraph on paper 27/50, 59.7 x 68.6 cm (23½ x 27 in.). Photo by Michelle Wojcik, courtesy of Galeria Cubana. The drypoint images created for this print are rich in narrative, colour and line. Collagraphy is a technique widely used in Cuba. Remarkable results are achieved using materials easily found in the environment. Guerra begins the process by selecting a special cardboard to serve as the base for the final matrix. He adds various materials to the board including paper, cardboard, acrylic, textiles and plastics that are durable enough to resist the pressure of the printing press. He limits the layering of materials so that the matrix is not stacked so high as to damage the printing paper. These materials create the elements of the overall composition. Every material added to the matrix leaves a different imprint depending upon its porosity. He adds different pastes, such as acrylics and enamels, in order to produce interesting textures. From there, Guerra adds figurative forms by drawing with a metal tip directly into the matrix. After completing the matrix, he begins the staining process. The entire matrix is filled with ink using a paintbrush, so that no area is uncovered. All excess ink is removed. The matrix and (normally handmade) paper is fed through the press. Afterwards, he adds some watercolour paint to the print, so that no two prints are alike.

LEFT Sarah Riley, *Alchemy II*, 55.9 x 76.2 cm (22 x 30 in.). The figure in this print is a drypoint from a Perspex (Plexiglas) plate. The background collagraph/monoprint started as a ghost print. The residues of red and yellow-green inks used in its first printing, for *Alchemy I*, were rolled with pale green, gold and turquoise-green inks using various-sized rollers. The inks, of different viscosities, repelled and blended with one another in interesting ways.

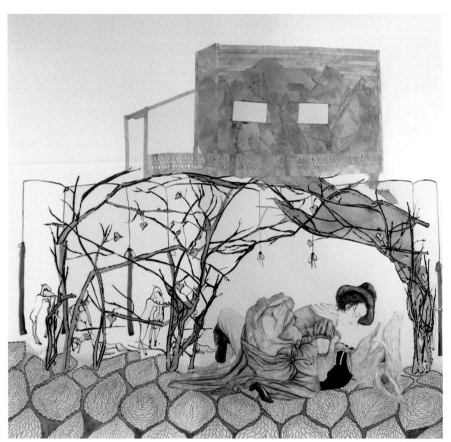

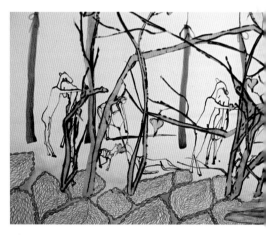

ABOVE Carrie Scanga, *Stick Cave*, 152.4 x 152.4 cm (60 x 60 in.). Collaged monoprint and drypoint over pencil and watercolour. Pale tones and soft graphite markings create a reflective mood.

RIGHT Carrie Scanga, details of *Stick Cave*.

PREPARING A PERSPEX (PLEXIGLAS) PLATE FOR DRYPOINT

If you are using a Perspex plate that is under 0.3 cm (1/8 in.) thick, you do not need to file or sand the edges; just file the corners to make sure that they do not cut the felts when printing. If the plate is thicker than this, you will need to carefully sand the edges as well, using fine sandpaper or a file. Sandpaper is easier to control if you wrap it tightly around a block of wood and staple it into place. Perspex is delicate, however, and you need to be careful not to scratch the surface with the file or sandpaper, as any scratches will show up in the final print.

Though copper is an easier material to scratch into, Perspex has the advantage of being transparent. You can lay the plate on top of a prepared drawing or photocopy and see this as you work. Note that you will need to be forceful to create swooping lines. More exacting lines, for descriptive areas, can be made slowly. Lines cannot be removed from Perspex: just make any slip-ups a part of the piece.

TIP YOU MAY FIND IT EASIER TO CREATE DRYPOINT LINES IF YOU MOVE THE PERSPEX CONSTANTLY, SO THAT YOU ARE PULLING THE DRYPOINT TOOL TOWARDS YOU AS YOU TRACE THE DRAWING.

TIP IN ORDER TO SEE WHAT YOU HAVE BEEN DOING AS YOU WORK, RUB A BIT OF ETCHING INK OR WATER-BASED CRAYON INTO THE LINES AS YOU GO ALONG, IN ORDER TO REVEAL THE IMAGE.

Kathleen Shanahan using an etching needle to create lines on a translucent sheet of Perspex. Note the photocopy under the Perspex, to aid image-making. Also note the purple line drawing, a guide made with water-soluble crayons on the underside of the Perspex sheet.

The finished and intaglio-inked plate of translucent Perspex. This plate was one of two used to create the **Akhenaton** and **Amphora** prints.

PREPARING COPPER PLATES FOR DRYPOINT

Copper is a wonderful surface for drypoint, as an etching needle will move more freely on this surface than on Perspex. You also have the ability to scrape and burnish any areas that you wish to erase from the design.

The tools you will need to prepare the edges of the plate are a de-burring tool and a metal file. Use the de-burring tool to eliminate sharp edges that can cut you and the press felts. Start at the end of an edge and pull the de-burring tool towards you. Do this two or more times until the sharp edge is eliminated. Repeat on the other three edges and then use a file to round and smooth the sharp corners. You will probably still have a bit of a rough edge underneath the plate, so be sure to remove this, too, with the de-burring tool.

You can remove deep unwanted marks with a scraper (like the one pictured on p.80). Use a small amount of oil or water and scrape the scratches off the plate. Remove the excess copper from the plate and then use a burnisher. Pressing down with the burnisher, move it back and forth and in circles to smooth over the surface that you have just scraped. You can also try fine steel wool or jeweller's emery paper. Use Brasso or other metal polish, with a piece of felt or a cotton rag, as needed to even out the surface and to polish the plate. A block of charcoal with water or oil also works well. Trying to polish a plate after doing the drypoint drawing does not work: it will remove some of the burr.

TIP ROOFING COPPER WORKS WELL FOR COPPER DRYPOINT PLATES; IT IS THINNER, BUT MUCH CHEAPER, THAN THE COPPER SOLD FOR ETCHING PURPOSES.

TIP IT IS A GOOD IDEA TO HAVE A MIRROR-LIKE FINISH TO THE PLATE BEFORE BEGINNING THE DRYPOINT.

The reason you want a bright, clear surface is so that the plate will not retain any ink in unmarked areas. But if you want plate tone or simply don't mind it occurring, then you need only remove the sharp edges and start your drypoint. Keep in mind that the harder you press, the more burr you will raise, the more ink the line will hold, and the darker it will be. As you work, use some etching ink rubbed into the surface to see an approximation of your progress.

TIP TO CREATE SOFT AREAS OF TONE ON COPPER, YOU CAN USE DIFFERENT GRADES OF SANDPAPER OR STEEL WOOL.

SHARPENING TOOLS

To sharpen the point of an etching needle, hold the tool at an angle and use circular motions on a sharpening stone along with a drop or two of oil or water. For the scraper, hold a flat side down on the sharpening stone and use straight movements and a drop of oil to sharpen.

INKING, WIPING AND PRINTING DRYPOINT PLATES

1. Prepare the ink in the same way as for collagraph printing (but you will apply it with a piece of cut card or an old credit card).

2. Card the ink on to the plate towards the image.

3. Remove the excess ink in the same manner as for collagraph or intaglio. Your goal is to wipe the ink off the non-imaged areas of the plate and to leave a rich deposit of ink in the drypoint marks. First, wipe off the excess ink with the card. Then, using an inky piece of scrim (changing to a cleaner one later), wipe in circular motions. Move the ball of scrim in a light, circular motion towards the image. Rotate the plate after every few wipes. Don't wipe too hard or for too long, as you could pull the ink from the drypoint lines.

TIP THE OBJECT, IN WIPING THE DRYPOINT PLATE, IS TO ONLY CLEAN THE AREAS OF THE PLATE WITHOUT DRYPOINT MARKS AND TO LEAVE THE INK ON – OR RATHER IN THE BURRS PREVIOUSLY CREATED ON THE PLATE.

4. While there is still some plate tone on the plate, finish the wipe with sheets of phone book pages or newsprint, using the flat of your hand. Keep the phone book page flat: don't wad it up. Use a light, circular motion and be gentle with the drypoint burrs.

5. Keep rotating the plate and changing to a clean area of the phone book page. Flip the phone book page over and start the process again. You may need to do this with three or four phone book pages or sheets of newsprint.

6. Wipe the edges of the plate with one more sheet of clean tissue or paper (or a rag), before placing the plate on top of a sheet of newsprint, or preferably the print registration package, on the press.

7. Marking and using the print package will ensure correct registration with the printing paper and subsequent layers if desired.

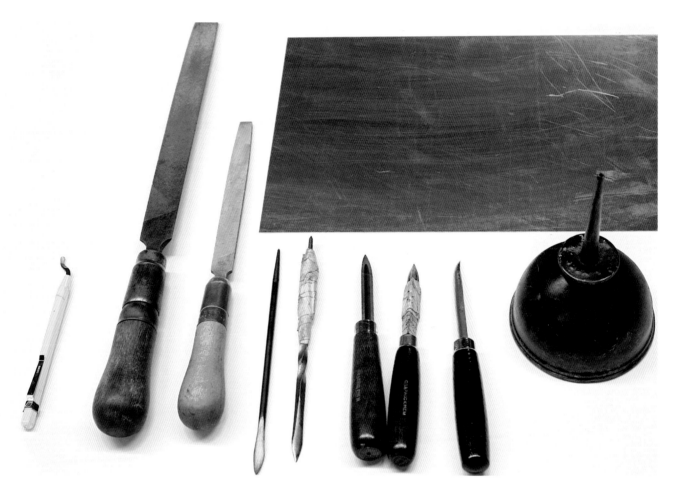

ABOVE **Tools for drypoint on copper: a de-burring tool, two files, two etching needles (one wrapped with masking tape to make it easier to hold), 2 scrapers (one wrapped with tape to prevent the sharp edges from cutting a finger), a burnisher, and 3-in-1 Oil in the can.**

RIGHT **Use the de-burring tool to remove sharp edges from the plate. Pull it towards you along each edge.**

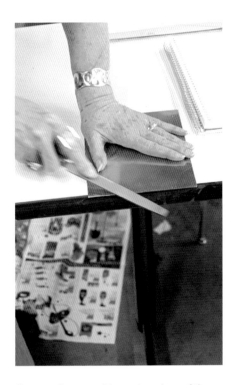

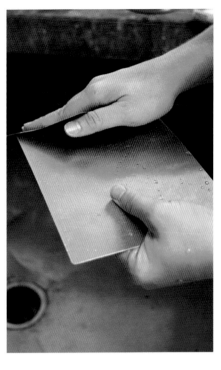

TIP WHEN FILING A PLATE, ALWAYS WORK OVER A RUBBISH BIN OR A PIECE OF NEWSPAPER SO THAT YOU CAN EASILY CLEAN UP ANY FILINGS. IF THESE SMALL PIECES OF METAL FIND THEIR WAY INTO INK OR SURFACES USED TO POLISH COPPER PLATES, THEY CAN EASILY SCRATCH AND RUIN PLATES.

If you prefer, use a file on the edges of the plate: try for a 45° angle on all edges. Use an angled stroke, moving downwards and away from you. Files cut in one direction. Also file the corners.

Smooth the edges with fine sandpaper as needed. Here, a fine wet-and-dry sandpaper is being used.

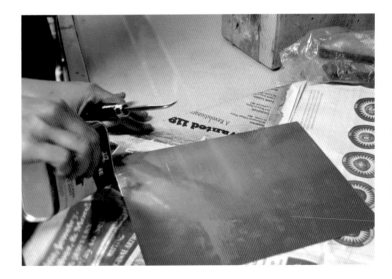

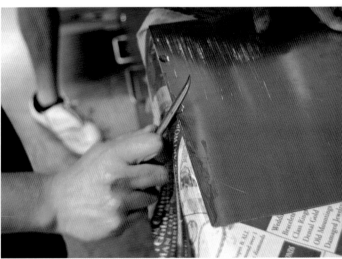

Use a little oil and a burnisher to finish the smoothing of the edges of the copper plate. This final step will prevent edges from retaining ink and printing an unwanted rough border around the edge of the image.

LEFT Calcium carbonate (powdered cleansers are made from a base of calcium carbonate, as are many toothpastes) can be used with water and a non-scratch pot scrubber or wet-and-dry sandpaper if the surface is really uneven or rough. For stubborn scratches, you can scrape and burnish.

ABOVE AND RIGHT Rinse the plate and dry it quickly, front and back, to prevent the water from tarnishing the surface. Polish the plate to a mirror-like finish with metal polish when it is dry.

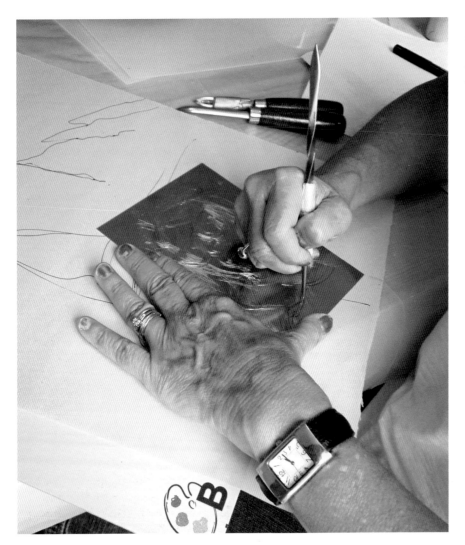

LEFT Kathleen Shanahan working with drypoint on a copper plate. This will be used in a multi-process print. Note the tape on the drypoint tool for cushioning the fingers and hand. You will notice that she has a burnisher and a scraper (also cushioned with tape) at hand for removing unwanted lines.

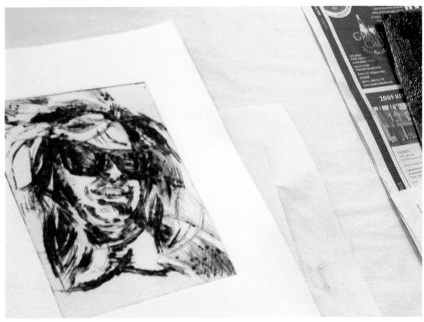

RIGHT Studying a proof from the copper plate to see if there are areas to add or to take out.

Bren Unwin, *Chiasmus*, Elemental series: Air, 5th state, 1/1. Drypoint, chine collé, 30 x 30 cm (12 x 12 in.). This elegant drypoint by British artist Bren Unwin was done on a copper plate. The plate was printed on to Hahnemühle paper using a thin Himalayan paper for the round chine collé. It is the fifth state of the plate, meaning that the artist scraped, burnished and redrew some or all of the plate after each state had been printed. On the development of the *Chiasmus* pieces, the artist comments: 'The term comes from phenomenological philosopher Maurice Merleau-Ponty's idea of "flesh" that describes an intertwining, or overlap, between a perceiver and their environment. In the *Chiasmus* series of prints, I explore the idea of an overlap between a perceiver and their environment by addressing the notion that an analysis of the way elemental qualities appear to us is at the root of all experience.'

Bren Unwin, *Chiasmus*, Elemental series: Water, 6th state, 1/1. Drypoint, chine collé, 30 x 30 cm (12 x 12 in.). This more emphatic version of the *Chiasmus* prints is printed on to Hahnemühle paper using a textured Japanese paper for the chine collé.

PRINTING A MIXED-MEDIA PRINT FROM COPPER DRYPOINT, PERSPEX DRYPOINT AND COLLAGRAPH PLATES; USING A STENCIL AND CHINE COLLÉ TO DEFINE A GHOST PRINT

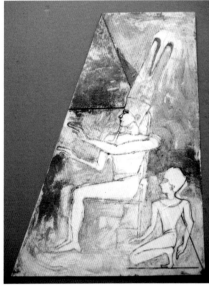

ABOVE LEFT The copper drypoint plate and a Perspex drypoint plate for *Garden of the Kings, Valley of the Gods.*

ABOVE RIGHT The third plate for *Garden of the Kings, Valley of the Gods*. This collagraph plate was created with glue, texture gels, mounting board and drypoint.

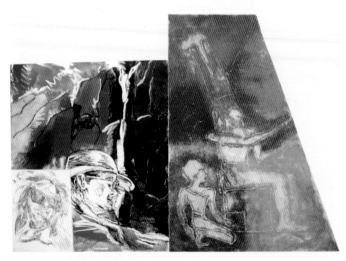

BELOW LEFT Kathleen Shanahan, *Garden of the Kings, Valley of the Gods*, 50.8 x 71.1 cm (20 x 28 in.). The collagraph plate was inked *à la poupée*. Colour was wiped on in 'zones' and blended at boundaries as it was carefully intaglio-wiped. The Perspex plate was inked and intaglio-wiped with black ink. Additional colour was applied using small rollers and worked into with rags, cotton buds and paper towels. The copper drypoint plate was inked with a transparent red and intaglio-wiped.

BELOW RIGHT Studying the assembled and inked plates on the press after the first printing. It was decided to pull a ghost print and then to add layers to strengthen the print as needed.

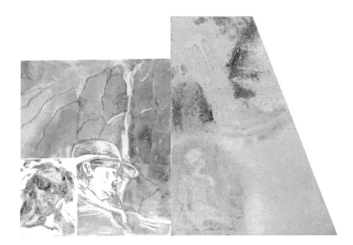

Above The first printing or layer of the ghost.

Above Kathleen Shanahan, *Garden of the Gods, Valley of the Kings* (ghost print), 50.8 x 71.1 cm (20 x 28 in.). The final version of the ghost print. It was decided to re-ink the collagraph plate. A stencil was used to block out the area of the pharaoh, saving and emphasising the light ghost printing of that figure. Printing this time was done in reverse, with the damp ghost print being placed face-up on top of the sizing catcher felt and a piece of clean newsprint. A stencil cut from newsprint was placed over the seated figure before 'eyeball registering' and dropping the newly inked collagraph plate into place. The Perspex-plate ghost was left as it was. The small copper plate was re-inked with blue and it was printed over a piece of fuchsia-stained rice paper chine collé.

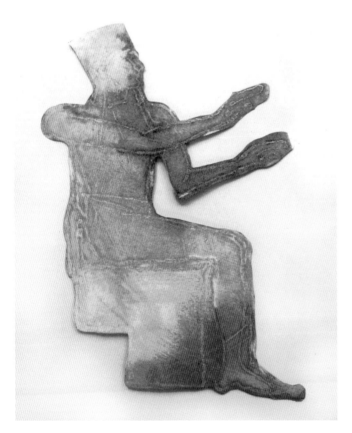

Above The stencil that was used to preserve the pale image of the pharaoh in the ghost print.

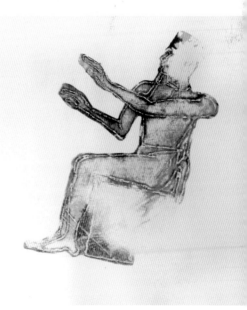

Above The stencil was flipped and printed (offset/counterproofed) on to a blank piece of damp printing paper.

ARTIST PROFILE

KATHLEEN SHANAHAN

Kathleen Shanahan, former Head of Drawing at Wichita State University, is a painter-printmaker who works primarily out of Wichita, Kansas. She has shown internationally in many group and solo exhibitions. An interest in cultural anthropology and cross-cultural comparison led her to spend a year of grant-funded research as Visiting Scholar at the National Museum of Ethnology, Osaka, Japan. Since then, her associative base has widened to include travels in Egypt and France, as evidenced in works shown here. Her printmaking experience has included a Lawrence Collaboration in Lithography Grant, Lawrence Art Center, Lawrence, Kansas, and summer lithography workshops at the Tamarind Institute/University of New Mexico, State University of New York, Albany, and the Wichita Center for the Arts. Shanahan's works are complex and joyous, a wonderful marriage of graceful beauty and kitschy clutter. 'My images are usually visual combines where disparate elements and characters share sometimes unlikely contexts. My "methodology" often involves juxtaposition and collaging in order to arrive at an image that implies a narrative. The viewer's interpretation further shapes and solidifies this narrative.' Of printmaking, she says that the surprise effects of monotyping, collagraph, chine collé etc. often dictate the next layer, or the next step or aesthetic decision, which adds more complexity to her narratives.

Kathleen Shanahan, *Pharaonic Sleep Disturbances*, 47 x 29.2 cm (18½ x 11½ in.). Processes used were drypoint on Perspex, collagraph, chine collé, hand-painting and collaged metallic foil. A powerful energy is held within the aggressive black drypoint lines.

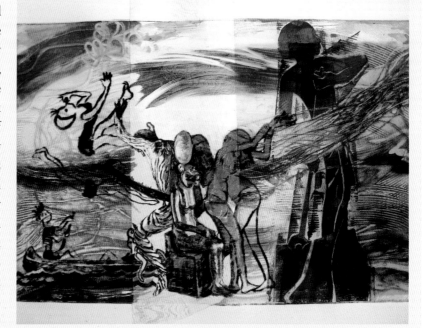

ABOVE Kathleen Shanahan, *Nubian Diving Lesson*, 40.6 x 49.5 cm (16 x 19½ in.). For this print, the processes were: drypoint on Perspex (black ink), collagraph, chine collé, hand-painting (lion goddess in centre), and monoprint. The image is lush with texture and seductive line.

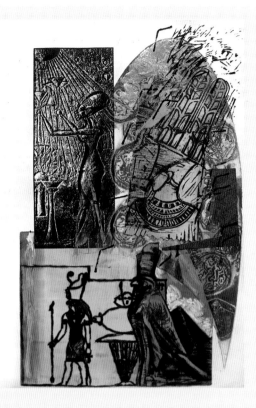

Left Kathleen Shanahan, *History of the Double Crown*, 29.2 x 48.3 cm (11½ x 19 in.). The processes used were polyester plate litho (upper left), collagraph (large partial oval to the right), drypoint on Perspex (black lines on bottom), monoprint, linocut (black lines of pharaoh, upper right), and collage (including metallic foil). Ink was rolled over the surface of the inked and wiped drypoint plate, and parts subtracted with cotton buds, tissues, cloths and brushes. Note the unique texture of the thick black lines, which, as you can see in the close-up, are actually made up of many tiny scratches. Also note, to the right, the way the green ink was wiped off the Perspex plate before printing, accentuating the pyramid with cloud-like shapes.

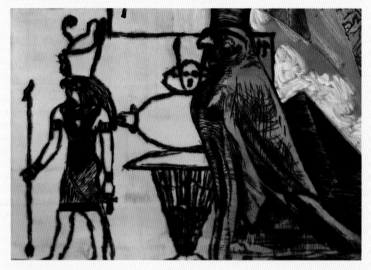

Above Detail of *History of the Double Crown*.

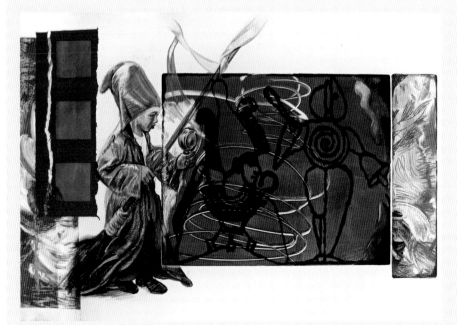

Left Kathleen Shanahan, *Nimbussed*, 30.5 x 48.3 cm (12 x 19 in.). Kathleen's processes were: drawing (figure on left), drypoint on Perspex, monoprint, and collage with a small amount of metallic foil. Note that spot colour passes were made with the roller on top of intaglio-inked and -wiped Perspex, with some passages removed using cotton buds, tissues, cloths and brushes.

ARTIST PROFILE

WILLIAM H. THIELEN

Bill works within the genre of abstraction. Having received an MFA in Fibres and a number of grants and awards, he has shown sculpture, drawings, paintings, installations and mixed-media works throughout the USA, including in Los Angeles and New York. Recipient of a National Endowment for the Arts Grant and a Banff Residency, this full-time artist, based in Carbondale, Illinois, undertook a printmaking project as a visiting artist in the autumn of 2010 at the Holland School of Visual and Performing Arts, Southeast Missouri State University. Working within the mediums of collagraph, drypoint, relief printing and lithography, Bill's lines, thin and thick, exacting and blurred, appear to be burning, like corrosive acid, within the rectangles that contain them.

He states: 'It is risky to trust the intuitive nature of emotions and the intellectual information that comes from experience and observation. For me, the only way to overcome this risk is in the language of abstraction ... The issues behind my work are personal and autobiographical. I work with these issues because they are my attempt to find my own true identity in a divisive social structure. Maybe in a way I am trying to find beauty or a momentary calm while existing in a society that is full of hostility and hatred ... These pieces are about looking for emotional truth in a post-modern world. The work is a way to say "I was here; I saw; I experienced; I felt." It is the desire to find a truth.'

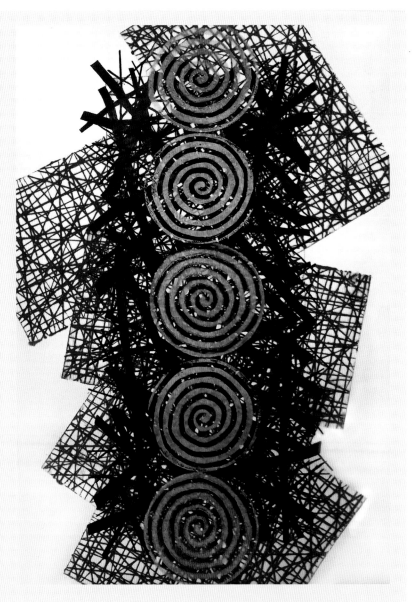

William H. Thielen, *Hard to Ignore*, 38.1 x 55.9 cm (15 x 22 in.). Note the soft blur of the red drypoint lines compared with the harder edges of the black litho lines and the blue spirals. Carved into a linoleum block, the spirals were surface-rolled and printed with a pale blue block-printing ink. The blue ink mixture beomes progressively more transparent as the spirals progress outwards from the centre. This print explores 'the issue of layering and opposites colliding to make a singular experience'.

William H. Thielen, *Lopsided*, 27.9 x 38.1 cm (11 x 15 in.). Note that the red drypoint plate from the previous image is used again in this smaller print. An additional drypoint plate, printed in white ink, is one of the top layers. The black base plates were made from circular stickers stuck on a piece of mounting board and covered with gloss medium. The yellow plate is a store-bought stamp.

William H. Thielen, *Everything Travels in Threes*, 38.1 x 55.9 cm (15 x 22 in.). This three-part print uses three different drypoint plates printed in white. The plates were created on thin Perspex with an etching needle and a ruler. Note the stamp of white dots in the lower right corner. Other techniques used are monoprinting with watercolour (the dots in centre), stencils, chine collé and hand-colouring with coloured pencils (the lines around the dots in centre). The top black area was rolled on to and printed from a sheet of Dura-Lar. The bottom third is a rainbow roll with stencils, drypoint etching, stamping and collaged elements, with Prismacolor pencils and acrylic. The driving force behind this print 'was one of layering and pushing extreme opposites together. Our life is not on one simple plane, but is a collection of past and present experiences, all colliding together ... The sharp delineation between each mood was created to stress how fast we can slide between these experiences.'

5 Relief printing

THE RELIEF PRINT

CARVED WOODBLOCKS HAVE BEEN USED TO PRINT on cloth and paper for centuries. With new materials that make the process easier – soft rubber printmaking blocks such as Soft Cut, Safety-Kut, Speedy Stamp and Speedball's Speedy-Carve – it is relatively simple to translate an image idea into a relief print or a stamp. Even unmounted linoleum is now available with an easier-to-carve surface. Both sides of the newer, softer blocks print easily and also work well as a monoprinting surface. Most online printmaking suppliers in the UK and the USA publish pages of instructions online, with details about transferring images or drawings to (as well as how to cut) these new relief surfaces.

Tools for carving linoleum and wood. Speedball lino-cutters are comprised of one handle with interchangeable blades.

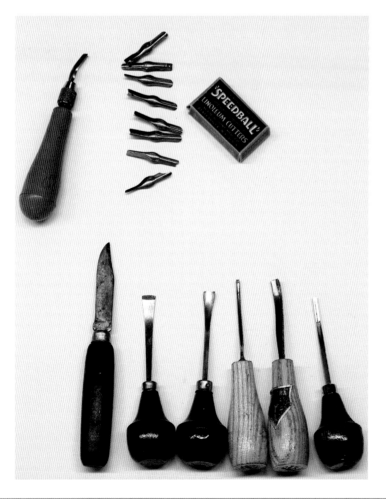

Any flat-bladed knife may be used to cut smaller blocks from large pieces of these relief-printing materials. To carve out non-image areas, Speedball and Economy make a handle that will accommodate various lino cutting blades. Printing from these types of relief surfaces, as well as from woodblocks, can be done on a press by applying pressure to the block, or by using a baren on the back of the printing paper to transfer the ink.

. .

TIP SOFT GRAPHITE DRAWINGS MAY BE TRANSFERRED TO THE NEW SOFT PRINTMAKING BLOCKS: FLIP THE DRAWING OVER ON TO THE SURFACE OF THE BLOCK, THEN RUB THE BACK OF THE DRAWING WITH YOUR FINGERNAILS OR A BONE FOLDER TO TRANSFER THE GUIDE. YOU MAY ALSO PRESS THE SOFT BLOCKS ON TOP OF FRESH INKJET PRINTS OR NEWSPAPER IMAGES TO TRANSFER A GUIDE FOR YOUR CUTTING TOOLS.

. .

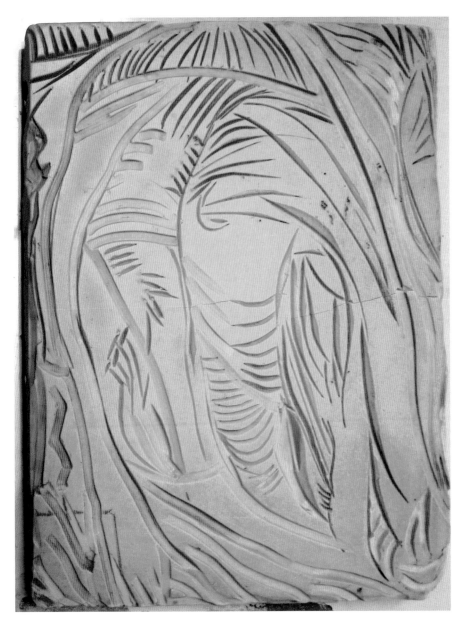

This plate was carved by first tracing the image, using carbon paper, on to a block of Safety-Kut and then carving away the areas that were not intended to print using Speedball lino-cutters. Note the different widths and shapes of lines cut with the different sizes and shapes of blades. The traditional method of carving areas to be removed, using a knife before using V- and U-shaped gouges to clear non-image areas, is not as necessary with this type of material as it is with wood.

Unmounted linoleum is easier to cut if it has been heated first on a hotplate or in an oven set to 93°C (200°F). Linoleum can become brittle with age, so cut it when it is new. Cut only to about halfway through the thickness of the linoleum. All of the monoprinting techniques mentioned earlier can also be done using linoleum as a matrix.

TIP TRY USING A RAINBOW ROLL TO INK UP A RELIEF BLOCK AND ADD AN INTERESTING SPATIAL FEEL, DIFFERENT FROM THE SOMETIMES FLAT LOOK OF BLOCK PRINTS.

Inking is done using block-printing or litho inks and a brayer or roller. These inks generally have a smaller pigment particle than etching inks and are more viscous. Etching inks may be used, but usually need the addition of a small amount of magnesium carbonate to change the ink to a stiffer consistency. I use a soft roller, although a harder roller will work on smooth, flat linoleum blocks and the new softer blocks. Papers to consider for relief printing include all printmaking papers, especially Japanese papers, which absorb the relief inks beautifully and dry to a matte finish.

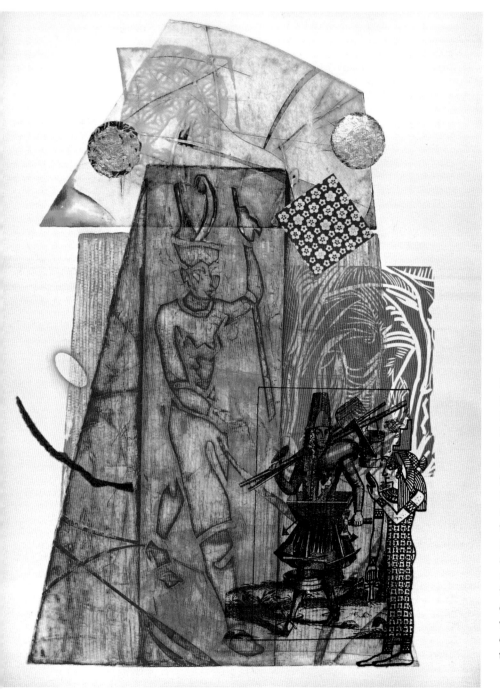

Kathleen Shanahan, *Isis, the Boatman and the Mason*, 34.3 x 52.1 cm (13½ x 20½ in.). In this image, on BFK Rives printing paper, the relief print (in orange at far right centre) was added to a print already in progress. Other processes used were: collagraph (note the extensive cutting away of the mounting board matrix with a sharp knife for the central figure before the plate was sealed; this gives the impression of another block print, intaglio-inked and relief-rolled with a bit of green), polyester plate litho (lower right), chine collé and collaged metallic foil. Note that in addition to a small amount of plate oil, a few drops of litho lacquer were added to the etching ink used on the collagraph plates in order to gain increased transparency.

MAKING A RELIEF PRINT

INKING

1. Put a small amount of block-printing ink on a glass or Perspex inking slab. Work it with a putty knife to warm it. Add ink conditioners as needed, working them into the ink before rolling it out into a thin film.

2. If the ink is too soft, a small amount of magnesium carbonate may be worked into the ink in order to create a crisper image.

3. When using soft papers, such as rice paper, add some ink modifier such as a light burnt copper plate oil to soften the ink and prevent it from sticking to the paper and tearing.

4. Use a roller or brayer to roll out a thin film of ink. If the ink is rolled out too thickly, it will have a puckered texture and make a 'puckering' sound. The right sound is a smooth, hissing one.

5. Roll the ink on to the plate from one direction only, in order to keep the edges of the cuts and the non-imaged areas of the plate as free from ink as possible. Some texture from the cut-away areas, however, is desirable in a block print.

PRINTING THE RELIEF BLOCK

1. Put a 2.5 cm (1 in.) stack of newspapers on the floor with the printing paper placed on top. Position the inked block face-down on top of the printing paper. Place newspaper over the block and use your feet and body weight to press the image on to the paper.

2. Relief blocks may also be registered using the print package, and run through an etching press. Adjust the pressure for the thicker plate. With an etching press, your image will be embossed, especially if you use damp paper.

3. Prints may be pulled by hand, using pressure from a wooden spoon or a traditional baren to transfer the image to the paper. Using thinner papers for handprinting allows you to use less ink and to see the image develop through the back of the paper.

4. Regardless of whether you print by hand or with a press, print some proofs first to test the viscosity of the ink in relation to the paper and the type of image you desire.

In relief printing, if a block looks like it is inked unevenly, it will print that way. If you use too little ink, you will not get an even print; too much ink will cause the block to print with uneven edges, blurring the image. Inked linoleum and the new softer blocks should have a smooth, consistent look before printing. When inked, woodblocks will still show some texture of the wood.

YOU WILL NEED

MATERIALS

◆ Block-printing ink
◆ Magnesium carbonate powder
◆ Burnt copper plate oil

TOOLS

◆ Putty knife
◆ Roller or brayer

TIP START WITH A THIN FILM OF INK. IT IS ALWAYS EASIER TO ADD INK TO A RELIEF BLOCK THAN IT IS TO REMOVE A COATING THAT IS TOO THICK.

TIP WHEN PRINTING BY HAND, THE ADDITION OF A SMALL AMOUNT OF REDUCING MEDIUM, LIGHT LITHO VARNISH OR BURNT COPPER PLATE OIL WILL MAKE THE INK EASIER TO TRANSFER TO THE PRINTING PAPER.

Left Andrew Arth, *Gear Nog* (1st stage), 27.9 x 38.1 cm (11 x 15 in.). For this print, Andrew made a stamp instead of carving from a block. He cut the image from Safeprint craft foam sheets. He then glued this to a piece of illustration board sealed with acrylic medium. He inked the stamp with a roller and black block-printing ink. 'The concept was a retrospective look at political and war posters. I was most influenced by Second World War and campaign posters from the 2008 election in the US ... The idea was that you might see this poster but have no idea what it means. The Korean language that I used is not important; just knowing that it pertains to you and it has significance to others ... Politicians will say anything to get votes and everybody has an opinion ...'

Above Andrew Arth, *Gear Nog* (2nd stage), 27.9 x 38.1 cm (11 x 15 in.). Andrew used the computer to size and arrange the Korean lettering before using a laser printer to print it on to a polyester litho plate (see pp.105–7). The poly plate was inked and printed in black.

Above Andrew Arth, *Gear Nog*, 27.9 x 38.1 cm (11 x 15 in.). Next, Andrew prepared a blend or rainbow roll of red and orange inks to roll on to the Dura-Lar sheet part of his print registration package. He then cut stencils to place over the previously printed sections of the words and the head. He also cut several triangular shapes from newsprint for use as stencils to create the rays moving outwards from Gear Nog. He placed the damp paper, already printed with the words, on the press; next, he added the stencils. Finally, he placed the rainbow-rolled piece of plastic on top and ran it through the press. Many simple techniques create a dynamic print.

Other versions of Andrew Arth's *Gear Nog*. Andrew made several variations while he was deciding on the final form that his print would take. In the first and third versions, he used a collagraph plate for the rays emanating from Gear Nog's head. The Korean writing says, 'Vote Gear Nog for President', and 'I promise to lower taxes and kill all humans'. He printed it out backwards from the computer via a laser printer, forgetting to flip it but, as he says, 'The context of the text pertains to the fact that politicians will say anything to get votes.'

Cyndi Wish, *Sunset*, 27.9 x 35.6 cm
(11 x 14 in.). 'In *Sunset*, I blocked out the
shape of the figures sitting on the log,
and then laid the paper on a slab of dark
blue and scribbled a trace monotype for
blue atmosphere around where the figures
would sit. The sunset is a woodblock with
a series of circular forms on it, rainbow-
rolled with orange and pink, and then
printed three or four times, shifting the
position of the paper on the block each
time. The brown that sits beneath the
black on the log is printed from the same
circular-shaped block, as is the blue on the
boy's pants. The girl's dress and shoes are
printed stencil monotypes, and the black
outline on the log and figures is a linoleum
block, which sits on top of the layers.'

Cyndi Wish, *Crystal Ball*, 27.9 x 35.6 cm
(11 x 14 in.). Again the woodblock of circular
shapes is used along with trace monotype
and stencil.

RIGHT Nancy Nicol, **Map Fragment G**, 27.9 x 35.6 cm (11 x 14 in.). Nancy Nicol is a storyteller and artist based in Wellfleet, Massachusetts, where she also directs Gallery 5. Her use of stamping and stencilling, with layers of thin papers obscuring earlier passes, can be seen in this piece – which also includes hand-painting. Note the repeated use of a circular stamp in the upper right area, in addition to the letters at the lower right.

BELOW Daniel Petot, **Signals**, 30.5 x 45.7 cm (12 x 18 in.). For his woodcut, Daniel printed a background, rolled out on a plastic (Dura-Lar) sheet. He carved a 12 mm (⅝ in.) block of pine with the woodcarving tools pictured above. Because some of the areas that he wanted to print were very narrow, such as the electrical cords, he cut around them first with a sharp, flat knife; then, using the woodcarving tools, he cut away from that pre-cut edge.

TIP IF YOU DO ACCIDENTALLY CUT AWAY A PIECE OF WOOD WHEN CARVING A WOODBLOCK, ALL IS NOT LOST. SIMPLY GLUE THE PIECE BACK INTO PLACE WITH WOOD GLUE. IF THAT IS NOT ENOUGH TO REPAIR THE DAMAGE, YOU CAN USE WOOD PUTTY TO RESHAPE THE SPOT. ONCE IT IS DRY, THIS CAN ALSO BE SANDED AND CAREFULLY CARVED.

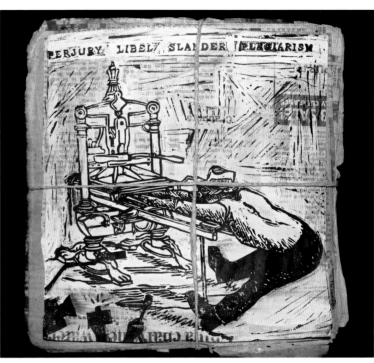

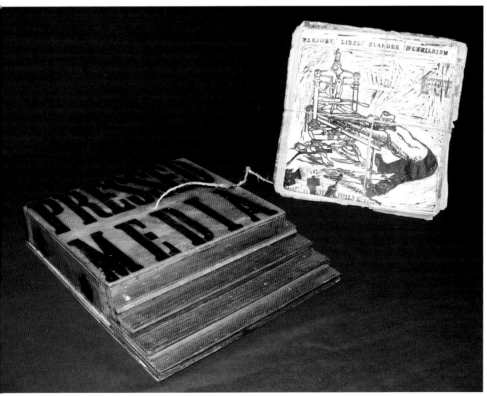

Joe Riley, ***Pressed Media***, 22.9 x 26.7 x 5 cm (9 x 10½ x 2 in.). Linoleum block print, stencil, spray-paint, newspaper and wood. 'Pressed Media was created as a solution for the Cooper Union home test, which is a series of assignments that Cooper Union issues to all applicants to its School of Art. The assignment that led to the creation of ***Pressed Media*** was as follows: Create or design a stage or platform for the redress of misdemeanours of public accountability. I chose to focus on crimes, both literal and figurative, relating to media. Printed on a stack of "pressed" newspaper clippings is an image of a media representative being "punished" by an old printing press for crimes of public accountability, namely perjury, libel, slander and plagiarism. This print is attached to a mock stage by a piece of twine. By connecting all these elements with draconian public punishment and the antiquated machinery and the Gutenberg press, I sought to also speak to the current decline of the print media and news industry.'

LEFT Jonathan Thompson, *Red Faces*, 38.1 x 55.9 cm (15 x 22 in.). Roughening the wood surface of three planks of wood with a wire brush before inking allowed Jonathan to print a strong woodgrain. He also carved out areas within the wood to allow for overprinting with two polyester litho plates.

BELOW (LEFT) William H. Thielen, *Untitled*, 38.1 x 55.9 cm (15 x 22 in.). In this print, the circular plates and also the black diamond shapes are linoleum cuts. These pair up with collagraph and drypoint plates to create a fun and vibrant ensemble. Interestingly, in this print the large, red linoleum plate with concentric circles was inked and wiped as an intaglio plate. The two half-circle plates at the top were relief-rolled and printed.

BELOW (RIGHT) William H. Thielen, *Untitled*, 38.1 x 55.9 cm (15 x 22 in.). The concentric circles plate appears again in this piece, printed twice. This time the plate was inked and printed in relief with white ink over a 'try everything' monoprint. The pink and red plates are drypoint on thin Perspex.

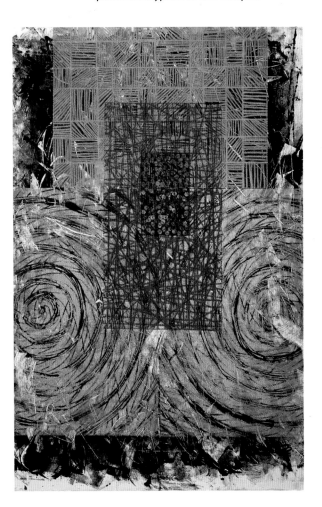

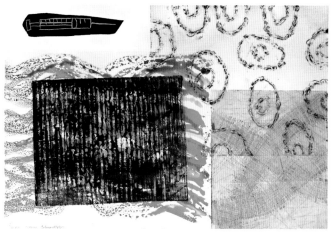

ABOVE Edward Haney, **Eyesore**, 38.1 x 55.9 cm (15 x 22 in.). Edward's series on disease and mental illness grows out of his hospital and volunteer work. 'This print explores how easily people just see a disease and not a person when they look at an HIV-positive individual. I used several different colours and plates, with varying transparency, to show the complexity of a human being both physically and mentally. The black syringe, a linocut, is a reference to the disease. The purple cardboard and syringe are relief-rolled. The plate in the upper right refers to blood cells and the gold plate to money (both intaglio-wiped). The watercolour was applied to a piece of Perspex lightly buffed with gum arabic.'

ABOVE Ryan Paluczak, **Untitled**, 38.1 x 55.9 cm (15 x 22 in.). With an old credit card, Ryan squeegeed acrylic paint across the surface of the printing paper. He inked up a carved woodblock (the rough horizontal lines) – which was larger than the paper – with black ink and printed the woodblock on to the painted paper using an etching press.

RIGHT Edward Haney, **Adjusting**, 38.1 x 55.9 cm (15 x 22 in.). 'The concept behind **Adjusting** is the physical and mental aspects of starting retroviral treatment. The medications can cause side effects that take some getting used to. The pill bottle and syringe are relief-rolled with black and filled in with coloured pencil.' The ugliness of this disease is conveyed through the crudity of the linocuts and the seductive beauty of the collagraph plate, which actually represents a microscopic view of a killer virus invading blood cells.

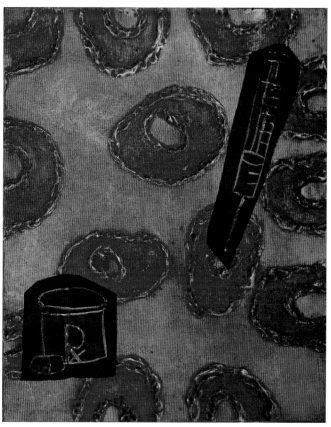

Brandi Macklenberg, *Inversion*, 38.1 x 76.2 cm (15 x 30 in.). The horror of the cattle trains taking prisoners to Auschwitz is the subject of this print. The numbers floating in the background are actual numbers branded on the prisoners' arms. A watercolour monotype of pale blood red was printed first. The train tracks are drypoint on Perspex. The numbers were created with a Sharpie pen (a permanent marker) on a polyester litho plate. The horror reverberating outwards is represented by the zigzag lines, which were printed in a transparent grey ink from a carved linoleum block.

PRINTING RELIEF, COLLAGRAPH AND DRYPOINT PLATES OVER PERMANENT WATERCOLOUR

ABOVE Sarah Riley, **Water Alchemy**, 38.1 x 55.9 cm (15 x 22 in.). In preparation for this print and the other **Alchemy** and **Arzanol** prints, I printed a large black and white computer photo image in two parts and taped it together. Cutting out the figure, I used it to both plan the series of prints and as a guide (under a Perspex plate) for making a drypoint plate. Using an etching needle and firm pressure, I scratched the linear figure into the Perspex plate. You can only see part of it in this version, the half-figure stepping into or floating off the page at the top left.

RIGHT After making the drypoint plate, I saturated a sheet of 250 gsm (140 lb) watercolour paper with water. I brushed permanent, acrylic-based inks on this sheet and let them spread out on the wet surface. With a previously prepared foam stamp (squares cut from a thin foam sheet and glued to a piece of illustration board) that had been rolled with green and gold acrylic paint, I pressed the paint into the still-wet inks on the watercolour paper. The paper was allowed to dry completely overnight.

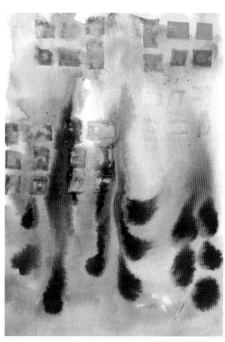

1 When the watercolour (made with permanent Indian inks) was completely dry, I put it in the soaking tray for about an hour. Watercolour paper has a lot of sizing in it and when you want to print on it, it is a good idea to let it soak long enough to soften it. Since the watercolour had been made using permanent inks, the colours do not loosen from the paper as ordinary watercolour would if you soaked it.

2 I then inked the collagraph dog plate (which you saw in a previous chapter). I used gold ink at the top and magenta at the bottom, as I wanted the magenta dog to appear to be growing out of the magenta washes of coloured ink.

3 Removing the permanent ink wash painting from the water. The watercolour paper was allowed to drain, and I then blotted it with the cotton towels you see to the right.

4 Placing the damp watercolour paper over the collagraph, which had been previously inked and intaglio-wiped with etching inks.

5 The watercolour paper with the dogs printed on top of it, but before the drypoint was printed in black at the upper left.

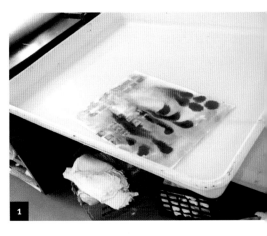

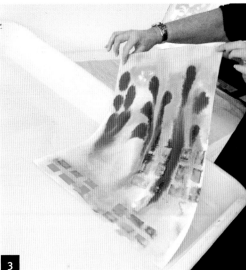

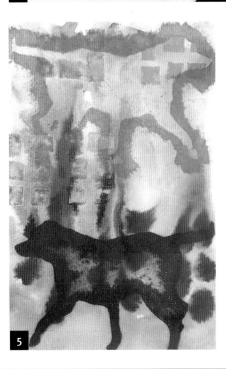

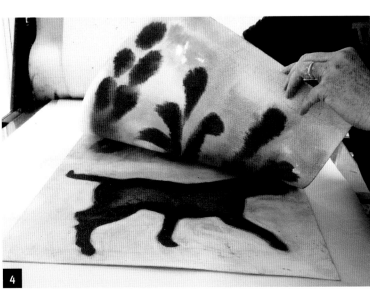

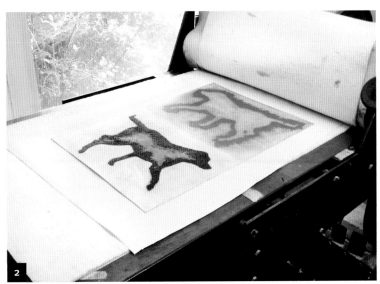

DRYING PRINTS

With the many processes and layers used in mixed-media prints, it is sometimes hard to flatten them. Here are three techniques for drying your prints.

1. The first way that I learned to flatten prints in art school was to tape them, with wide brown paper tape (the kind that you must wet to activate the glue), to large boards of plywood, Masonite or even to a smooth wall – any smooth surface to which the tape would adhere. To use this technique, make sure the damp print is flat before wetting the tape and fastening it to the board by overlapping the edges of the print with about 2.5 cm (1 in.) of tape. If you turn the print to face inwards, you can save the deckled edge by carefully cutting and slipping a palette knife between the print and board (when the print is completely dry). Carefully work it far enough away from the drying board to allow you to gently pull the remaining edges away from the board. Peel any remaining tape from the back of the print. Also, working from the back of the print, smooth the edges of the deckle with a wooden baren or spoon. Preferably, the board should be painted or sealed in some way before taping prints to it. When taping a print to face inwards, place a sheet of newsprint or heavy tissue paper between the print and the board to keep the board clean. The print is dry when it is warm (not cool) to the touch.

2. A slightly (but evenly) damp print can be placed in a dry-mounting press preheated to 93°C (200°F) for 60 minutes or more. Protect the face of the print with blotting or tissue paper. The damp print must be perfectly flat before drying it in this way. Any wrinkles in the damp print could be permanently creased into it if it is not flat when you start. If the print ripples and buckles again after drying it with the dry-mounting press, you must start the process over again and dry it for longer and/or at a higher temperature.

3. A third way is to dry prints in between layers of white fibreboard or other inexpensive pressed board. Tape the edges of the boards, as they tend to disintegrate over time, and use blotters between the print and the boards. Make a sandwich of boards, print and blotters, weighting everything down with heavy objects such as books and metal plates. Change the blotters daily. Again, prints will be warm, not cool, to the touch when dry. It is best to dry them for several days and to remove them during a period of dry weather. Store in a dry place.

6 Polyester plate lithography

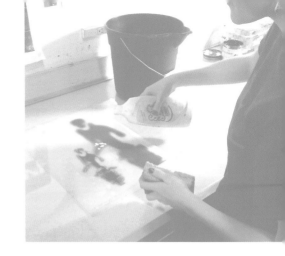

POLYESTER PLATE LITHOGRAPHY was originally developed for industrial lithographic reproduction. It is a quick way to incorporate lithographic imagery into mixed-media prints, and the plates are less expensive than photo-sensitised aluminium litho plates. Polyester plates are not light-sensitive and, if kept clean and free from grease, should last a long time. They are non-toxic to process and you only need a photocopier or a laser printer to 'develop' a photographic image. Both photocopier and laser printer use toner, made of minuscule plastic beads, which is fused to the plate with heat to image it. (Inkjet printers will not work for this process, as they are not toner-based.) The laser-printed or photocopied image can, in turn, be inked and transferred multiple times: to paper, with an etching or litho press; or on to wood, plastic, paper, and even curved forms by hand-printing with a baren, wooden spoon or anything you can use to apply firm pressure to the back of a plate. In addition to photo-imaging, most permanent waterproof (liquid) imaging materials (and some dry ones) will hold ink on a polyester plate.

There are several manufacturers of these polyester litho plates, also termed 'poly plates'. Every manufacturer provides directions for imaging and processing along with the plates, and this can also be accessed online. Polyester litho plates may be ordered from most printmaking suppliers. Handle the plates in such a way that you avoid putting fingerprints or dents on the surface. Fingerprints will retain ink and print.

TIP BOTH SIDES OF MOST POLYESTER PLATES CAN BE USED FOR IMAGING.

IMAGING WITH A PRINTER OR PHOTOCOPIER

YOU WILL NEED

MATERIALS

◆ Polyester plates for lithography

◆ Toothpaste, fountain solution or a non-abrasive cream cleaner containing calcium carbonate (like Soft Scrub or Ecover)

TOOLS

◆ A photocopier or laser printer

Polyester litho plates may be cleaned prior to imaging with a non-abrasive cream cleaner like Soft Scrub or Ecover, toothpaste or fountain solution. This will remove unwanted grease and fingerprints. (Each manufacturer has its own version of a fountain solution for plates, which also may be used to clean plates before imaging. CAUTION: Fountain solution can contain harmful glycol ether. Read the label, follow directions for ventilation requirements and stay safe.)

Assess the highlights in the photo or drawing that you want to transfer to a poly plate by photocopier or laser printer. Images that have clear whites for highlights work best. Too much grey in the highlights will cause an image to overfill and turn dark when inked; images with a higher degree of contrast work better. Dark grey and even some light grey areas tend to merge with black areas. Using a halftone texture can also work well if you want that look (see below).

USING A PHOTOCOPIER

1. If available, choose 'Transparency' as the paper type.

2. Feed the polyester litho plate through the manual feed slot of the photocopier.

USING A LASER PRINTER

1. Once on a computer, photos and other images can be collaged, layered or otherwise altered, and greyscale can be corrected using image editing software such as Adobe Photoshop.

2. Before printing from a computer, lighten your image overall in the layers palette (Window > Layers). Use the opacity setting: even with 100 per cent whites as highlights, lower the opacity to 70–80 per cent overall before printing, or try some halftone settings as described below. Experimenting with one image, you can achieve many variations, some more effective for your needs than others.

3. Select Rough under Paper Source on the printer settings to ensure the highest heat setting for the printer.

4. Colour photos may be photocopied on to a plate in greyscale, or changed into greyscale in Photoshop on a computer, using Image > Mode > Grayscale. Adjust as needed in Levels (Images > Adjustments > Levels) and then laser-print on to a plate.

5. Colour separations can also be printed from a colour photo or image using Photoshop and a laser printer. First change the colour mode: Image > Mode > CMYK. Then, from the channels palette (Window > Channels), highlight and print each channel separately on to its own polyester plate. As the channels

TIP ANYTHING THAT CAN BE SCANNED, OR HAS BEEN CREATED ON A COMPUTER (OR CAN BE TRANSFERRED TO IT) CAN BE PRINTED ON TO POLYESTER LITHO PLATES VIA A LASER PRINTER. OPEN THE BACK OF THE PRINTER WHEN PRINTING LARGE PLATES SO THAT THE PLATE WILL RUN THROUGH THE PRINTER FLAT.

TIP REMEMBER TO FLIP THE IMAGES IN THE SETTINGS SINCE LITHOGRAPHS, LIKE INTAGLIO AND RELIEF PRINTS, PRINT IN REVERSE.

print in greyscale, it is helpful to mark the back of each plate with its colour – cyan, magenta, yellow or black – using a permanent marker.

6. Create registration marks on the image in Photoshop using the brush tool. Or create them in the printer settings: File > Print with Preview; choose Output under Show More Options and then select Registration Marks. (This window is also where you can check Emulsion Down to flip your image.) Another way to place registration marks on the plate, front or back (they are translucent) is with a permanent marker. Use a window or a lightbox to align the layers.

TIP WHETHER USING A PHOTOCOPIER OR A LASER PRINTER, RUN THE PLATE THROUGH TWICE (THE SECOND TIME USING A PIECE OF BLANK PAPER TO COPY, OR AN EMPTY IMAGE FILE WHEN LASER-PRINTING). THE HEAT FROM THE SECOND RUN WILL HELP ENSURE THAT THE TONER FUSES FULLY TO THE PLATE.

Sarah Riley, *Attend*, 22.9 x 35.6 cm (9 x 14 in.). For this litho, pieces were cut from various photos that had been de-saturated and posterised in Photoshop before printing onto paper. The printer was poor quality and left quite a few unwanted lines in the images, but the paper collage was assembled anyway. Then, using a photocopier set to the 'Transparency' setting, the collage was copied on to the polyester plate. Because of the grainy nature of some photocopies and what is called the 'bridging effect', the lines, which are very apparent in the original collage, have mostly disappeared in the final inked and printed lithograph.

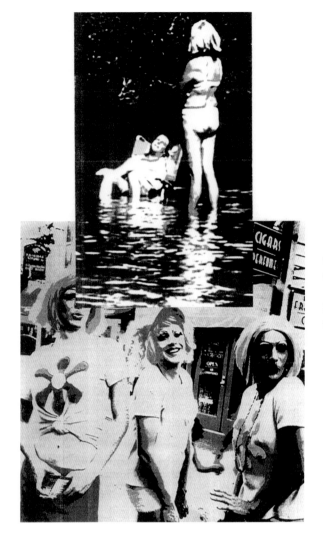

LEFT This is the collage that was copied on to the polyester plate. Note the unwanted lines from the printer.

BELOW A detail of the inadvertent lines from the printer.

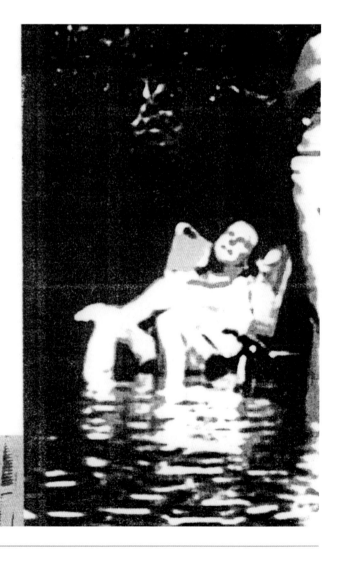

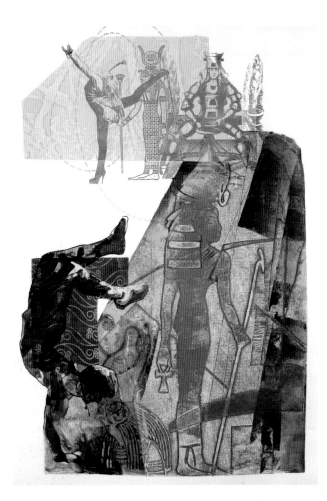

Kathleen Shanahan, *Many Moods of an Egyptian Banquet*, 35.6 x 55.9 cm (14 x 22 in.). The processes used for this print are varied. They include collagraph, stencil, hand-painting, polyester plate litho and chine collé. The image printed in grey at the top was transferred, via photocopier, to the polyester litho plate. It was then inked and printed to create a part of this print's vivid narrative.

Sarah Riley, *Every Object I Could Compile*, 76.2 x 76.2 cm (30 x 30 in.). This print, in three parts, started as a photograph of a large classical head. It was worked in Photoshop with various filters and brushes. It was printed, using a large inkjet printer, over an Indian ink drawing of a still life. The ink drawing was done on a piece of hot-pressed Arches 250 gsm (140 lb) watercolour paper. The next layer was a polyester litho plate of a doll's head, inked in red and hand-printed. The text was also hand-printed from a poly plate litho with gold ink. I often use rag watercolour or printing papers when printing from an inkjet printer. When both the paper and the ink are archival quality, they help to ensure the longevity of the print.

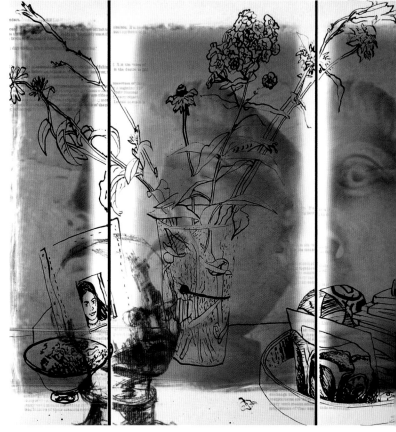

Points to keep in mind when printing on to polyester litho plates

• Size the image depending upon the size of the polyester plate. Reserve a non-imaged border of at least 2.5 cm (1 in.) around the image; 5 cm (2 in.) is even better. This makes the plate easier to ink.

• If you are using a 15 cm (6 in.) brayer for inking, smaller images will work better. But it is also possible to ink larger plates well with a small roller. Use no pressure when rolling the plate with ink, and roll in many different directions.

• High-contrast images work well. Avoid a completely grey image, no matter what the value range. The close spacing of toner dots in grey areas can cause the printing ink to bridge the gaps, causing the greys to fill in and become darker. Thus, grey areas can merge together into one value and obscure the image.

• To reduce this filling-in or bridging effect, make sure the lightest areas are completely white. Use the colour-picker in Photoshop to verify this. Use a full range of values. Lighten the highlights and mid-tones of the image in Levels (Image ----> Adjustments ----> Levels) and then overall in the opacity box on the layers palette. Change the opacity to 70–80 per cent before printing.

• Reducing the opacity creates fewer dots of toner. The dots will be further apart and so help to counter the bridging effect. To check this effect, print the image on paper at 100 per cent opacity and then at 70 per cent. Look at the dots through a loupe. The image will also be lighter overall, but the plate, after inking, will be darker.

• Good halftone also works well if you want this type of texture. See below.

• I have also used the film grain filter in Photoshop (Filter ----> Artistic ----> Film Grain) to apply a dot that is further apart in an image, but still lowering the opacity before printing. The effect of the applied film grain and lower opacity is minimal in the final print because of the filling-in (bridging effect) of blank areas of the plate surrounding the toner dots. I used the film grain filter on the black background plate for Old Paris is Gone.

ABOVE AND OPPOSITE Daniel Petot, *Self-Portrait*, 27.9 x 38.1 cm (11 x 15 in.). Each layer as proofed on newsprint: cyan, magenta, yellow and black. Instead of using colour separations from one colour photograph, for this print Daniel Petot photographed each layer separately in black and white, using coloured gels in front of the camera lens. After scanning each photo, he layered and aligned the images in Photoshop. He drew registration marks with the brush tool and printed each layer on to polyester plates, labelling each on the back with its respective colour. This elaborate process adds an unsettling effect as each layer is almost, but not quite, aligned. His method reflects his background in photography, film and mechanical engineering. Note the way that the image was allowed to bleed beyond its edge, adding a contradictory element to this impressive self-portrait.

HALFTONE

A printed halftone image simulates the photographic halftone. In a laser-printed halftone the illusion of continuous tone is created by many minute dots that may vary in size, shape or placement. To create your halftone, start with a photo or a scanned image that is the size you wish to print (allow a border of at least 2.5 cm/1 in.) and that contains at least 150 ppi (118 pixels per cm). The 'pixels per inch' or 'ppi' refers to the number of pixels (picture elements) in a raster image (bitmap). Raster images do not scale up easily if they do not contain enough pixels. Without enough ppi (not to be confused with dpi, or 'dots per inch' – this pertains to printers; image files contain pixels), the square pixels enlarge and become jagged, or the image blurs. Therefore, take your photos using the highest setting on your camera. Or you can scan an image at 600 ppi (236 pixels per cm) or more, making it possible to crop it and still have a decently sized image with enough pixels to work with.

To check the size and resolution of an image in Photoshop look at Image > Image Size. To change the size, uncheck the box next to Resample Image, but do check Constrain Proportions before changing the width or height of the image. You will be able to see the number of ppi in the image, relative to its new size, next to Resolution in that same pop-up window. You will need a resolution of 150 ppi to print an image at 75 lpi (lines per inch; halftones are based on lines), which is the general recommendation for hand-printed lithography plates. The number of ppi should be twice the lpi. Remember that 'lpi' refers to the number of lines of halftone dots per inch that the printer prints; 'dpi' refers to the number of dots per inch that the printer is able to print. Most laser printers are set to print at 1200 dpi.

Image ┄┄> Image Size window.

PREPARING AND PRINTING GREYSCALE HALFTONES

1. Since the number and density of dots actually printed on the plate determines the value of your image and that value will, as mentioned before, print darker than it appears on the plate, you should next go to Image > Adjustments > Levels and move the Highlights and Midtones arrows to the left. Do this until the lightest areas of your image are free of greys and the mid-tone greys are lighter in value as well. This, along with changing the lpi setting, will reduce the bridging effect mentioned above.

1 Image ┄┄> Ajustments ┄┄> Levels window

2. If you are going to print the litho plate in one colour, change the image mode to greyscale: Image > Mode > Grayscale. Then change the mode again by choosing Image > Mode > Bitmap. In the pop-up window, set the Output ppi to 150 (or the pixels per cm to 59); the Method should be Halftone Screen; click OK.

3. The new pop-up window will ask you to set the frequency, angle and shape of the halftone screen. Set Frequency to 75 lines per inch (or half the

2 Image ┄┄> Mode ┄┄> Bitmap window

ppi), Angle to 45° (the best angle for single-colour printing), and set Shape to Round.

4. These guidelines and recommended numbers for halftone are only a place to start. I used a setting of 650 ppi for the output, a frequency of 85 lpi, an angle of 45° and set the shape to Line for the figure and shadow in the Spectacle prints. I tried several different settings before deciding on the one I eventually used. Print your trial settings on paper first and look at them through a loupe. This will help you decide which settings to use. Remember that the higher the lpi (screen frequency or lines per inch) setting, the closer together the halftone dots and vice versa.

5. When you are ready to print the greyscale litho plate, go to File > Print with Preview. (These instructions are for the HP 5100 and similar laser printers.) Select the printer, and the size and orientation of the polyester plate, under Page Set-up. Click OK. Under the image of your file, you will see a drop-down menu: choose Output. You have already entered the screen settings but you can flip the image to print in reverse by checking Emulsion Down. In addition, you can use Registration Marks to add these if you have not already drawn them on the image. Now click on Print and in the pop-up window, again make sure that the correct printer is chosen. Under Image Quality in the drop-down menu, choose 1200 for the Printer Resolution. Under Printer Features, choose Rough for the Media Type and then click Print.

3 Halftone Screen window

4 Close-up of the halftone printed on the polyester litho plate used in the Spectacle prints.

5 Print with Preview window

> **TIP** AFTER PRINTING ON TO THE POLYESTER PLATE, RUN IT THROUGH
> THE PRINTER A SECOND TIME USING A BLANK FILE SO THAT THE TONER
> WILL BE HEAT-SET AGAIN. THIS SHOULD MAKE FOR BETTER ADHERENCE
> OF THE TONER TO THE PLATE. TO FACILITATE THE PRINTING OF LARGER
> PLATES, OPEN THE BACK OF THE PRINTER BEFORE PRINTING.

PREPARING AND PRINTING COLOUR SEPARATIONS IN HALFTONE

For his self-portrait print, Daniel Petot used settings of 150 ppi, 75 lpi and a round shape for the CMYK colour separation halftones. To avoid a moiré pattern (an interference pattern created by the overlapping halftones), he set the angles as follows: cyan 15°, magenta 75°, yellow 90°, and black 45°.

To create colour separations from a full-colour image, make sure you are in CMYK mode: Image > Mode > CMYK. Then go to the channels palette, Window > Channels, and highlight each channel separately before printing. You will notice that each time you choose only one channel of the four displayed, the image appears in greyscale. Next, choose File > Print with Preview. Select your printer, and the size of your polyester plate, under File > Page Set-up and click OK. Under the image of your file you will see a drop-down menu: choose Output. This is also where you can flip the image to print in reverse, by checking Emulsion Down. In addition, you can add registration marks if you have not already drawn them on the image. Click the Screen button, uncheck the box for Use Printer's Default Screens, type in 75 for the lpi and set the angles as follows: cyan 15°, magenta 75°, yellow 90°, and black 45°. Click OK.

Print with Preview and Page Setup windows

Image Quality window

Now click on Print. (If you get a message that 'Your image is more than 2.5 times the halftone screen frequency', click Cancel and go back to the file to change the image resolution to 150 ppi, Image > Image Size. You only need a resolution of 150 ppi to print a litho plate of 75 lpi. If the message persists, click Proceed). In the pop-up window, again check that the correct printer is chosen. Under Image Quality, choose 1200 dpi for the Printer Resolution. Under Printer Features, choose Rough for Media Type and then click on Print.

After printing on to the polyester plate, run it through the printer again using a blank file so that the toner will be heat-set a second time. This will help fix the toner to the plate. Repeat these steps for each colour channel.

You can investigate halftone more fully in Photoshop's Help program. A search in it brings up a number of useful topics, including 'Specifying

Printer Features window

halftone screen attributes'. This section is based on information from Kevin Haas's website (www.wsu.edu/~khaas/resources/index.html).

IMAGING A POLYESTER PLATE AUTOGRAPHICALLY

Autographic imaging is imaging by hand as in an autograph. In addition to toner imaging, most permanent (waterproof) liquid media (and some dry ones) may be used to image a polyester plate. Among the most popular are:

◆ Ballpoint pens, permanent ink (allow to dry for 24–48 hours)

◆ Permanent Indian ink

◆ Permanent marker pens (Sharpies)

◆ Acrylic paint

◆ Acrylic floor polish (add a small amount of permanent ink so that you can see it easily when applied to a plate)

◆ Screen filler, such as Speedball or Lascaux Screen Filler

◆ Toner tusche: photocopy toner mixed with water to create washes

◆ Lithocoal (similar to a charcoal stick made from compressed toner powder) or photocopier toner

◆ Hard litho crayons # 4 and # 5.

TIP ALL IMAGING MATERIALS FOR POLYESTER PLATES BENEFIT FROM A BONDING WITH HEAT. TONER TUSCHE AND STRAIGHT TONER POWDER MUST BE HEAT-BONDED.

Clear acrylic floor polish may be applied with a brush, a sponge, any textured material, or with a nib and pen. Reticulated washes may be created with toner tusche (recipe follows) or diluted screen filler. Adopt a 'less is more' approach, as washes tend to hold more ink than their appearance on the plate might imply. This is true of all media applied to polyester plates. Liquid media should not be applied thickly: add water as needed to thin them. The material should fill the crevices between the dots on the plate, but any material painted too thickly above the surface risks being chipped or pulled off when the plate is inked.

Gum arabic and watercolour crayons may be used as resists under liquid imaging materials. Let the imaging materials dry, then heat-set for 30 minutes at 93–107°C (200–225°F) on a hotplate or in an oven. Wash resists off with water before inking. If using toner tusche (caution: use a dust mask and gloves when handling dry toner particles), make sure that the toner is adhered to the plate or it will wash off. Check it with a cotton bud, not your finger. If the cotton bud comes away clean, the toner has bonded to the plate. In fact, any acrylic-based media, permanent markers or pen drawings will benefit from being heat-set after they have dried. This aids in the polymerisation or strengthening of the acrylic material and in the bonding of it to the plate.

You can draw with Lithocoal and photocopier toner powder and manipulate it until you are satisfied with the image. Heat-bond it to the plate as described above.

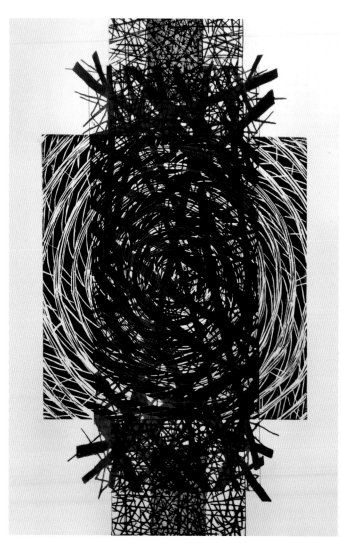

William H. Thielen, *Just the Facts,* 38.1 x 55.9 cm (15 x 22 in.). This print is a combination of a vertical litho plate in the middle (the blocky, thick lines), and drypoint plates at either end. A collagraph plate, made from glued-on small dots, was printed underneath the drypoint plate. The litho plate was imaged with a thick, square-tipped permanent marker and then heat-set for 45 minutes on a hotplate set to 107°C (225°F). The thick lines were extended beyond the established litho print boundary with Prismacolor pencils. A linoleum block was carved and used for the large square plate of circles in the centre. Simplicity reigns, yet the intimacy of the artist's hand is revealed in the irregularities and insistency of his chosen elements of form. 'Once again, these prints explore the issue of layering and opposites colliding to make a singular experience. Sometimes, the layers may be of different colours; other times, they may be monochromatic. Either way, my intent is to reflect the human experience.'

Sarah Riley, *Spectacle*, 38 x 48.3 cm (15 x 19 in.). All the images in this work were printed from polyester plates on top of a watercolour background monoprint (see p.49). The red lines on the right side of the print were created with a brush on a polyester litho plate using clear acrylic floor polish. It was then heat-set before inking and printing. The image of the woman and the shadow were imaged on to another plate from a photograph manipulated in Photoshop and printed from a laser printer. The rippling pools of water were created on yet another plate with toner tusche and a brush. The toner tusche was then heat-set for an hour at 93°C (200°F). The pools were printed with a silver ink.

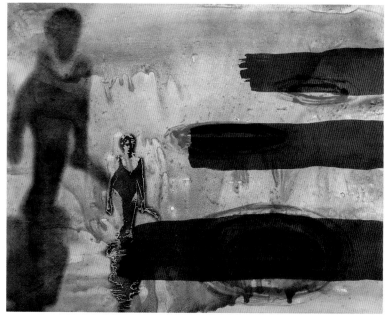

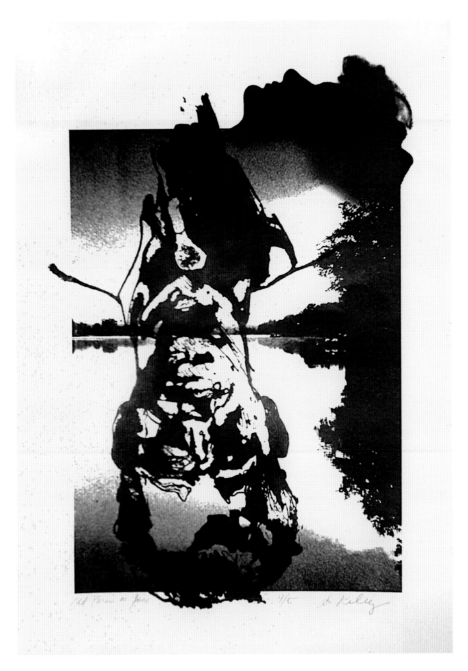

ABOVE Sarah Riley, ***Old Paris Is Gone***, 25.4 x 38.1 cm (10 x 15 in.). The black parts of this image were assembled using Photoshop tools and then printed from a laser printer on to a polyester plate measuring 30.3 x 45.7 cm (12 x 18 in.).

RIGHT The plate with the dark brown head was painted with washes of Speedball Screen Filler. The brown plate was inked before this photo was taken and, though it looks opaque, it prints more transparently. The black and white plate was printed from a laser printer at 70 per cent opacity. Compare the plate with the final litho print to see the changes in value. For imaging polyester plates with a laser printer, lighter is better.

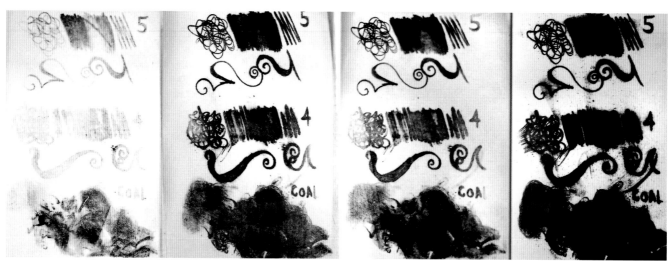

Above This series of proofs was made by Elizabeth Coffey, print studio assistant at Southeast Missouri State University. She drew on the polyester plates with litho crayons #4 and #5, as well as Lithocoal. All materials were heat-set at 93°C (200°F) for 45 minutes. These are four proofs from a series of seven.

When printing proofs, work slowly to build darks. If you over-ink at the beginning, it is hard to keep the plate from becoming overly dark and you may have to start again. The last proof, in fact, is starting to fill in. See the section on under-inking and printing below for remedies. It may take from four to six proofs in order to get the plate to print in the way that it should. Once it is printing correctly, pull your edition, trying to achieve a consistent number of times when rolling ink on to the plate and recharging the roller.

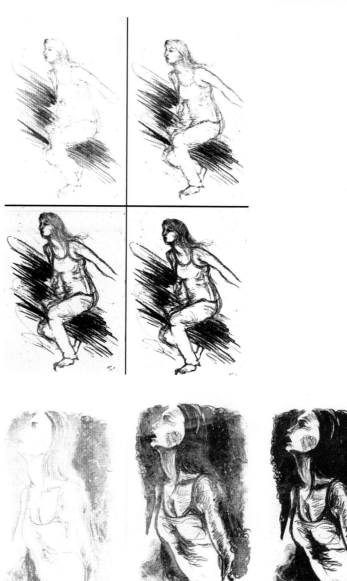

Right (middle) Elizabeth Coffey used ballpoint pen and a china marker for this image. The plate was heat-set. These are four of six proofs pulled to reach the bon à tirer stage. (A bon à tirer is the first proof that satisfies you. This proof is the print that you want all others to match.)

Right (bottom) Another set of Liz's proofs. This time, the image was made with litho crayons #4 and #5. Lithocoal (photocopier toner) was smudged into the background. The plate was heat-set before proofing.

USING TONER TUSCHE

Toner tusche is a wash-type material. Use with a brush to create watercolour-like washes, lines and shapes. The following instructions describe how to make, apply and heat-bond it to a polyester litho plate.

1. You can make toner tusche easily by mixing toner, obtained from used toner cartridges, with water in a 1:2 ratio. Add a drop or two of dishwashing liquid to help the toner disperse in the water. Some rubbing alcohol may be added, as well as a small amount of Photo Flow or Liquitex Flow Improver for interesting effects. CAUTION: When handling dry toner, always use a dust mask and gloves. Wipe up any spilt toner with a damp cloth or paper towel and dispose of it in a closed container so that toner dust is not inhaled.

2. You may also want to add a drop or two of Speedball or Lascaux Screen Drawing Fluid or gum arabic to make the mixture more controllable. (Add cautiously: too much of these additives can prevent the toner from adhering to the plate.)

3. For imaging the plate, add water as needed to dilute the toner tusche washes.

4. Work with it, wipe it off and try again until you have the result that you want. Keep tusche washes light in value, as the plate will print darker than it looks. A 50 per cent grey wash, instead of black, is a good place to start.

5. Heat-set in the oven on a baking sheet or on a flat-topped hotplate on top of a sheet of paper at 93–107°C (200–225°F) for 30 minutes or longer. You can push the heat higher and sometimes force a quicker bonding of toner to plate, but watch the plate carefully so that it does not scorch, melt or warp at the higher temperature.

6. You may wish to cover the plate on the hotplate with something like a metal baking dish, or push the heat a bit higher if the toner is taking more than 30 minutes to fuse. Remember that if you cool the plate down during the process, you will have to begin the timing all over again. The times are not cumulative.

7. Test the toner to see if it is securely adhered before inking and printing by rubbing with a cotton bud. Using your finger to test the plate is not advised, as this will add grease that will hold ink and print. Even if the cotton bud comes away clean, it is advisable to heat the plate for as long as 60 minutes to ensure that the toner is bonded well. Though you may be able to ink and print the plate well after 30 minutes of bonding, the extra heating helps the toner withstand the abrasion of the sponge and the cleaning of the plate.

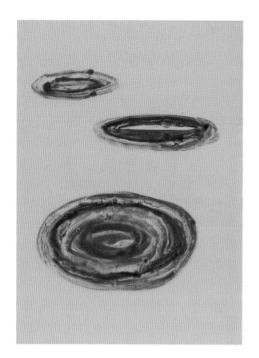

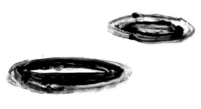

Left Sarah Riley, ***Ripples from Spectacle***, 27.9 x 38.1 cm (11 x 15 in.). This plate, created as part of the Spectacle print, has been painted with a toner wash and heat-set. The image next to it is the bon à tirer. Note the watercolour-like wash effects.

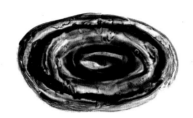

Below Ryan Paluczak, ***Objects of Self [:Loathing:]***, 27.9 x 38.1 cm (11 x 15 in.). For this image, toner tusche was loosely applied to the plate. Quite a bit of Liquitex Flow Improver was then added. After Ryan had heat-set the plate, he rinsed the flow improver from the plate leaving behind only the fused toner. So much Flow Improver was added that it actually prevented the toner from adhering to parts of the plate. A 'mistake' that yielded an interesting result.

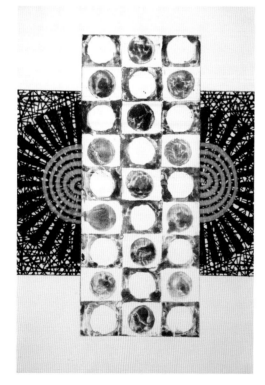

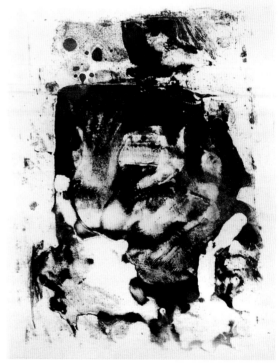

Above William H. Thielen, ***Additional Support***, 38.1 x 55.9 cm (15 x 22 in.). The central portion of wash-like circles in this print was created on a polyester plate with toner tusche. The red starbursts on the sides were printed from a linocut. It was then overprinted with black lines from a drypoint Perspex plate. On top of this, curved lines from a carved linoleum plate were printed in light blue.

INKING AND PREPARATION OF A POLYESTER LITHO PLATE

INK PREP

Regular black lithography inks may be used to ink polyester litho plates. Black litho inks are, however, often too stiff to be used straight from the can without modification for hand-imaged plates. If ink is too stiff, it can pull an autographic image right off the plate.

Most colour litho inks are soft enough to use without modifiers. If they are too loose, they may form scum as you roll the ink on to the polyester plate. You can reduce the formation of scum by adding a small amount of magnesium carbonate powder to the ink. Work it in well with a putty knife. Most etching inks also work well or can be stiffened as needed with magnesium carbonate.

1. Stiff black litho inks should be worked on a glass or Perspex inking slab with a putty knife until they warm up. Take a small amount out of the can.

2. Add a few drops of litho varnish #3 or lightweight burnt copper plate oil to the ink and work it in as needed to reduce viscosity. Roll out a small amount on the inking slab with a brayer or roller until you have an even, smooth surface that creates a soft hissing sound when rolled.

3. On the other hand, if you are using particularly loose coloured litho ink or etching ink, work in a small amount of magnesium carbonate powder to prevent scum forming.

4. There are a couple of other ways to reduce the formation of scum on the plate.

• (a) Reduce the amount of ink on the inking slab; scrape off some of the rolled-out ink and rework the remaining ink to an even, smooth surface: it should be smooth, not puckered in appearance. Too much puckering means too much ink.

• (b) Add a small amount of vinegar and some gum arabic to the wiping water.

TIP PUT SOME PETROLEUM JELLY (SUCH AS VASELINE) AROUND THE EDGE OF THE INK CAN BEFORE CLOSING IT. THIS SAVES A LOT OF TIME AND STRUGGLE WHEN TRYING TO REOPEN THE CAN LATER.

Ink worked and rolled out.

WATER PREP

1. Prepare two buckets (containing approx. 4 litres/1.05 gallons in total) of clean water. To one of these, add a small amount of vinegar, compatible fountain solution (WARNING: this contains harmful glycol ether), or gum arabic to lower the pH of the water to between 4.5 and 5.5. In Cape Girardeau, Missouri, it takes 1½ tablespoons of vinegar to lower four litres of water to the appropriate pH. As the print progresses, I usually end up adding about 1 tablespoon of gum arabic as well if the plate 'scums' excessively. This pH-balanced water is for dampening the plate during the inking-up process.

2. In addition, have available some small squares of felt (the inexpensive kind from a hobby store will work), two cellulose sponges (one to be used with the pH-balanced water only), and some Soft Scrub or toothpaste (or other calcium carbonate based, non-abrasive cream cleaner like Ecover or Cif).

3. The bucket of plain water will be used for cleaning off scummy areas with the cream cleaner or toothpaste and the felt or sponge. The edges of the plate should also be cleaned before printing. Use the felt squares by themselves, or a damp piece of felt/sponge and the cream cleaner or toothpaste to remove unwanted areas of ink. Also, the plain water can be used for any other type of cleaning-up. Doing this will keep the pH-balanced plate-dampening water clean.

Materials set out for dampening the litho plate

THE INKING-UP PROCESS

1. In addition to the prepared lithographic ink, you will need a soft inking roller or brayer or other student or craft rubber roller. A roller the size of the image is ideal, but a soft 15 cm (6 in.) Speedball brayer also works fine.

2. Squeeze a small amount of pH-balanced water from the sponge on to a clean spot on the inking slab and then place the imaged plate on the slab and move it around until it is stuck in place.

3. Wet the plate with the wrung-out sponge and pH-balanced water. Lightly wipe the surface of the plate. The plate is hydrophilic, or water-loving, and will absorb water in the non-imaged areas. The water will form beads on the imaged or greasy areas of the plate.

4. Wring out the sponge again so that it is even less damp, and wipe the surface of the plate a second time.

TIP CLEANING A LASER-PRINTED PLATE WITH THE CREAM CLEANER, TOOTHPASTE OR THE PLATE MANUFACTURER'S FOUNTAIN SOLUTION BEFORE WETTING AND INKING GETS RID OF ANY TONER SCATTER AND UNWANTED GREASE, AND THE PLATE WILL INK UP WITH FEWER PROBLEM AREAS. (DON'T TRY THIS WITH PLATES IMAGED AUTOGRAPHICALLY.)

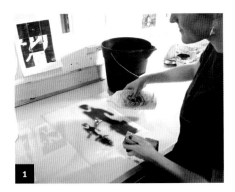

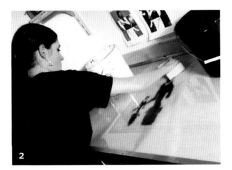

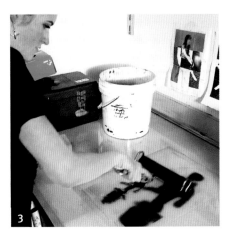

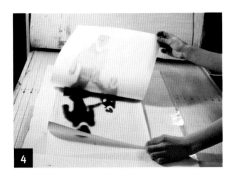

5. The plate should be damp, without a wet sheen or beading, before you roll the ink across its surface. Too much water on the plate can cause the ink to emulsify and will increase the formation of scum. Too little water, or dried-out areas on the plate, will cause the plate to fill in with ink.

6. Use little ink and light to no pressure as you pass the roller quickly across the damp surface of the plate and back again in a snap roll. If you apply too much pressure, you will leave marks on the image that will print.

7. Wipe the plate with the sponge dampened in pH-balanced water between each double roll.

8. Ink the plate by rolling the brayer in varied directions across the plate and back: lengthwise, diagonally and breadth-wise.

9. If non-imaged areas fill with ink, you have allowed the plate to dry out between rolls, or you may be charging the roller with too much ink. If this happens, sometimes just wiping the plate vigorously with the damp sponge (wetted with pH-balanced water) will remove it. Also, try reducing the amount of ink on the roller. Keep wiping and rolling with little to no pressure, in a snap roll, until the ink lifts from the overfilled areas.

10. If unwanted spots of ink refuse to clear, simply take a second sponge or piece of felt, dampened with the plain water, and a small amount of toothpaste and clean off the ink. Begin the wiping and rolling process again.

11. If the plate continues to fill in or to form an excessive amount of scum, remove some of the ink from the slab and/or add more vinegar and a small amount of gum arabic to the pH-balanced water. Some printers recommend adding $\frac{1}{2}$ teaspoon of citric acid powder to the wiping pH-balanced water to help prevent scum. You may also need to add some magnesium carbonate to the ink.

12. In my experience, slight scum is not usually a problem, as it seems to take care of itself as you wipe and ink and print proofs.

13. Re-charge the roller as needed and keep a count of how many times you re-charge, as well as roll, the surface of the plate. Four to six complete wipe-and-ink passes are necessary before pulling a proof.

14. Do not over-ink the plate at the start. Bring up the image slowly, proofing at least four times before arriving at edition quality. Exceptions to this rule are plates imaged with solid areas of heat-bonded acrylic floor polish. They can be inked heavily and need only be proofed once, usually, before editioning.

1 Liz Coffey cleaning a laser-printed polyester plate with Soft Scrub (or a non-abrasive cream cleaner) before inking.
2 Dampening the plate with sponge and pH-balanced water before inking. Note the two buckets.
3 Inking the dampened plate quickly and lightly.
4 Pulling the first proof: develop your print slowly, pulling at least four proofs before reaching the desired bon à tirer stage.

USING AN ETCHING PRESS

You may use either a litho press or an etching press to print your plate.

1. You can print without felts by lowering the press roller to the press bed and putting more newsprint, mounting board, a piece of Perspex, or even a litho tympan over the printing plate. Adjust the pressure as needed.

2. I have found it convenient to leave the felts in place when printing other processes such as collagraphs and drypoints on the same press. It saves time, and the editioning of a print involving several techniques easier.

3. If you add a piece of Perspex, it raises the print package to the level of most etching or collagraph plates.

4. Use a light to moderate press pressure, depending on the image.

5. The plate may also be printed by hand. After inking, place the plate over the printing paper (or other surface) on a flat surface and rub thoroughly from the back with a baren or the back of a wooden spoon. A piece of graphite may also be used. Sponging a bit of water onto the back of the plate makes the litho easier to print by hand. Tape the paper to the plate, or vice versa, in order to be able to lift it from time to time to see how the image is progressing.

THE PRINTING PROCESS

1. Place the inked polyester plate on the etching press on top of newsprint or the print registration package. If you do not already have the press bed covered with a solid acrylic sheet, place a piece of Perspex, larger than the plate and paper, underneath them. This smooth, hard surface helps in the print the litho plate.

2. You may use registration marks on the print package or on the back of the polyester plate, as it is translucent. See 'Registration' below.

3. Use newsprint or other inexpensive paper to proof the plate the first four to six times.

4. Place the printing paper on top of the plate and then a piece of newsprint over everything to keep the felts clean. You may also choose to place the plate over the paper for sight registration. The polyester plate may be printed face-up or face-down.

5. Wiping and inking consistently between printings brings up the image slowly.

6. Trying to work too quickly, with an excess of ink, will mean that only one or two prints can be taken before the image begins to fill in and becomes too dark with over-inking. You risk losing the image, especially in the grey areas, and you may have to start all over again with a new plate.

'T-bar' registration, using the back of the polyester litho plate and the back of the paper. Place the paper in position over the plate. You can see the markings on the back of the poly-litho plate because the plate is translucent. The markings on the backs of the printing paper will guide you in its placement. Multiple colour plate registration is possible when every sheet of paper and every colour plate is marked identically.

7. When printing the fifth proof or so, use good printing paper. When the image starts printing well, this is the best time to continue printing the entire edition. Even though it is possible to repeat the printing of the image later, it may never print in the same way again.

8. The paper you print on may be dry or damp. If you need a crisp print, use a damp paper. Some printing papers have a harder finish than others and benefit from a quick soaking and blotting with a towel before printing.

9. For printing in multiple colours, use dry paper for reasons of registration. Normally, the lightest colour is printed first. Print all of one colour and allow it to dry before printing the next.

10. Pull all prints to match the first proof that satisfies you (the *'bon à tirer'*).

CLEANING THE PLATE

1. Clean the plate by printing it several times on sheets of newsprint.

2. Clean off any remaining ink with washing-up liquid and water, or a small amount of toothpaste. Rinse well. Be careful with crayon- and tusche-imaged plates: they are delicate. You may want to clean a delicate hand-imaged plate by printing it several times onto newsprint only.

3. Machine-imaged plates that are solidly bonded can take a lot of cleaning without ill-effects.

4. Do not use oil to clean the plate: it will ruin it.

REGISTRATION

You may register plates in many ways. Four of the most popular ways follow.

• The plate is translucent and may be registered by sight (or 'eyeballed') into place on top of a mixed-media or multi-layered colour print;

• You may use the print registration package to register the plate and printing paper as described earlier under the collagraph section;

• When imaging a plate in Photoshop, place registration marks on each layer. These marks will print, along with the image, on to polyester plates through a laser printer. The plate and paper can then be visually lined up when press-printing because of their translucent nature;

• You may use 'T-bar' registration. Mark the back of the plate(s) with a permanent marker and the back of the paper with pencil, as in the images above.

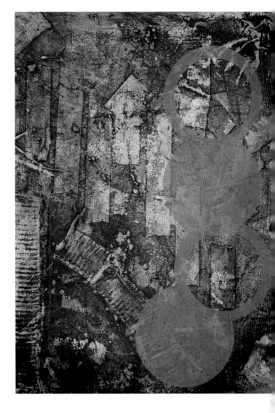

Tyler Dunn, *Geometry III*, 22.9 x 30.5 cm (9 x 12 in.). In this print, a polyester litho plate was imaged with circles made in Adobe Illustrator. They add a sobering counterpoint to the lush image of the viscosity-rolled collagraph plate beneath. Just enough transparency was added to the blue litho ink. You can see the erratic collagraph plate, made from bits and pieces of cast-off materials, pushing through the pristine circles.

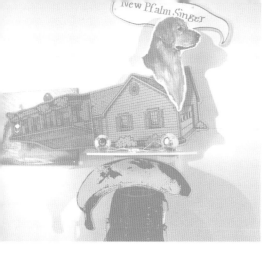

7 Other directions

PRINTMAKING TODAY PLAYS with the given definitions of painting, drawing and sculpture. It continues to go its own modest, beautiful way and, in addition, it is breaking open other art forms. Modern and contemporary printmaking, long based in drawing skills, is being recast as a trans-disciplinary practice. There are seven artists in this section who include printmaking techniques primarily or tangentially in their work, but are carrying it forward in a way that puts a premium on formal and conceptual diversity and interdependence.

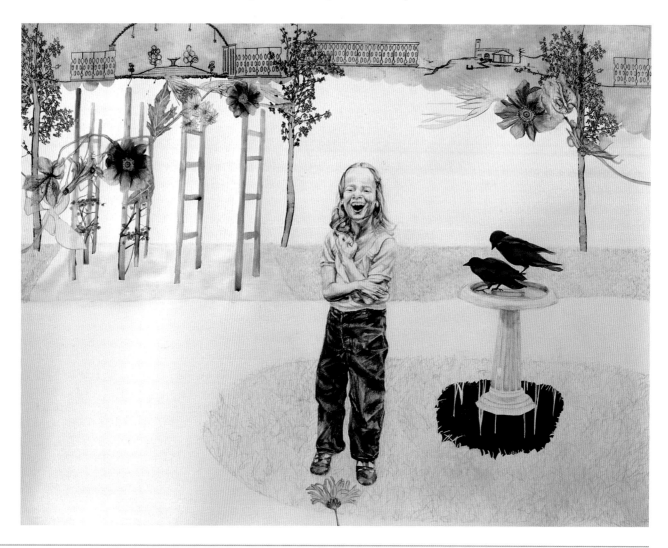

ARTIST PROFILE

CARRIE SCANGA

My exploration is concerned with space, the intimacy of individual experience and the liminal aspects of memory. Buildings and cultural myths both are terrains that become saturated with people's stories through use and circulation.

Working in two dimensions, I have developed my own hybrid of drawing/painting/printmaking, in which I intuitively rework the paper until a space and story emerge.

My installations reflect my lifelong interest in the relationship between our internal physical sense of occupying bodies and our perceptions of occupying architectural space. I push the delicate material of tracing paper to its limit, relying on its folds to lend stability to forms. Over the course of an exhibit, the paper eventually gives way to gravity, and at the exhibit's closing, the work is recycled.

I have been fortunate to receive numerous residencies, awards and fellowships, which have helped me to develop my work and ideas. I am grateful to the Fine Arts Work Center in Provincetown for two consecutive winter fellowships, the MacDowell Colony, Artspace, and Sculpture Space for residencies, and for fellowship grants from the Pollock Krasner Foundation, the New York Foundation for the Arts and the Ludwig Vogelstein Foundation. My studio practice is currently in Maine, where I also teach at Bowdoin College.

Opposite Carrie Scanga, *Coronation Snapshot*, 116.8 x 147.3 cm (46 x 58 in.). Charcoal, watercolour, collaged etching (aluminium etched with a copper sulphate-based etchant) on paper.

Above Carrie Scanga, *You Will Be and I Will Be and She Will Be*, 152.4 x 152.4 x 182.9 cm (60 x 60 x 72 in.). The materials used in this piece are papier mâché, wood, paint and mulberry paper, with intaglio printing over charcoal drawings.

The intaglios were etched on aluminium with a copper sulphate-based etchant (combination of copper sulphate and sodium chloride)

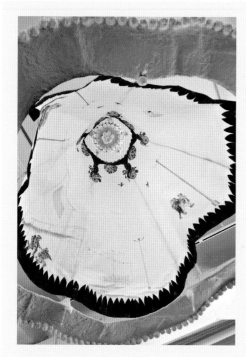

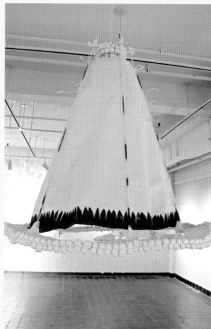

Left Carrie Scanga, *Tree House*, 152.4 x 152.4 x 182.9 cm (60 x 60 x72 in.). Papier mâché, wood, paint, and paper with charcoal drawings and collaged etchings (aluminium etched with a copper sulphate-based etchant).

Right Carrie Scanga, *View From High Places*, 548.6 x 426.7 x 304.8 cm (216 x 168 x 120 in.). Tracing paper with intaglio printing and thread. A tower of translucent paper bricks was stacked on a grid of string to a height of 274.3 cm (9 ft). The strings spanned the space, partially obscuring a 365.8 x 182.9 cm (12 x 6 ft) drypoint print (this used three large pieces of Perspex printed on a press) that hangs on the back wall of the gallery. Viewers ducked under the higher set of strings in order to enter the space between the tower and the drypoint print. The scene depicted in the drypoint print is the perspective imagined from this high window in the tower.

ARTIST PROFILE

JOE RILEY

Apathy toward the surrounding world, others' lives and even ourselves is truly 'quiet desperation'. Through my art, I seek to raise a voice against such silence. In doing so, I explore the boundaries between traditional gallery art and street art. I use printmaking, spray-paint and mixed-media techniques to question the pervasive apathy of modern society. I focus on themes like the impermanence of the human condition, the ephemeral nature of art, and the tragic lessons of historical events such as the Holocaust.

Joe Riley, *Praying Skeleton # 1*, stencil and spray-paint on canvas, 132.1 x 190.5 cm (52 x 75 in.). Stencilling was one of the first ways developed to replicate imagery. The use of stencils or pochoir, as it is also known, dates back to as early as 500 CE.

Today, thin acetate or polyester sheets and paper (which the Chinese and Japanese have used for centuries) are both popular materials for creating stencils used in painting and printmaking. Graffiti artists employ stencils and spray-paint to create street art.

Young artists such as Joe Riley use it extensively in their art. 'Process is very important to me. I create large-format stencils by hand, separating and cutting out each layer, or colour value, of an image. These works can take as long as 200 hours to complete. The nature of my stencils is such that each image or painting must be built up layer by layer, value by value, and they are often unrecognisable until this process is complete. The act of carefully building each work of art is an integral part of my creative process, and I find it to be just as important, if not more important, than the final piece.'

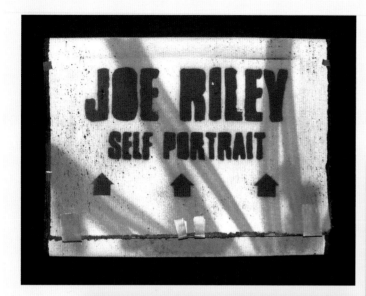

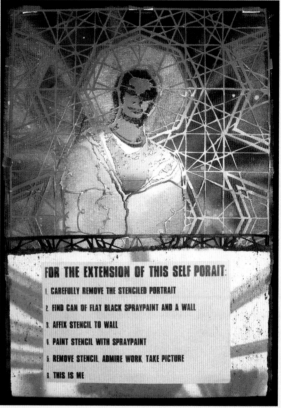

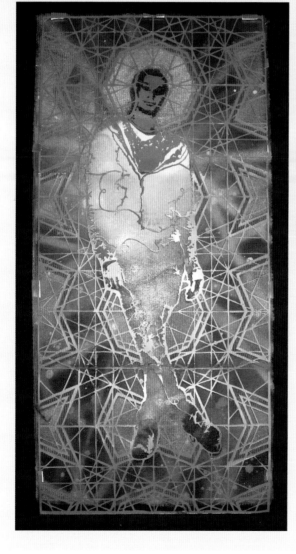

Joe Riley, *Full-Length Self-Portrait*, stencil, spray-paint, cut-out stencil on canvas, 35.6 x 73.7 cm (14 x 29 in.). 'I created this work to engage the viewer in a participatory manner. As the viewer unfolds the piece, directions instruct him or her to remove the stencil (self-portrait image) from its background and paint it on a wall somewhere. The portrait can either be extended in this manner or it can stand alone as a work of art without viewer participation/interference.'

ARTIST PROFILE

BREN UNWIN

Dr Bren Unwin is a British artist who works from a research perspective. She is President of the London-based Royal Society of Painter-Printmakers and has work in both national and international collections. Her particular interests include relationships that exist between an active perceiver and his or her dynamic environment. Materials, actions and ideas are thus explored in association with the mediated character of experience. Her work ranges from the directness of drypoint on copper to making installations and archival digital prints. Connecting all her work is an interest in mark-making and textures gathered over time through personal experiences.

Bren Unwin preparing to hang her work at the 'IMPACT 6' conference, Bristol, UK.

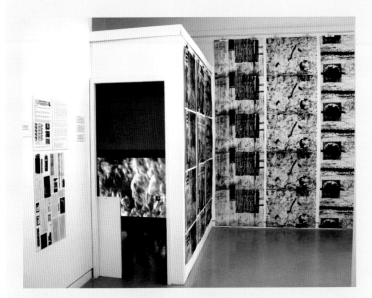

Bren Unwin's installation for the 'IMPACT 6' conference. Video and six long intaglio prints replicate the idea of movement in two forms. The viewer perceives both direct experience through the videos and a mediated experience from the prints on paper, both mediums using replication and size to create an all-enveloping environment. (Three long lengths of paper were printed from the first stage of the intaglio plates and three from the second stage of the plates.)

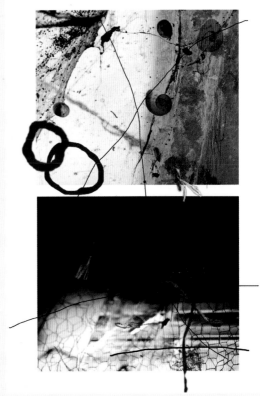

Bren Unwin, *Quillet Series, Onion Shed*, archival digital print on film, backlit, 42 x 59 cm (16½ x 23¼ in.).

ARTIST PROFILE

CHRIS WUBBENA

Chris has been awarded many grants and has exhibited widely, including in the exhibition 'A Southern Perspective on Prints: 2005 New Orleans Triennial' at the New Orleans Museum of Art. In addition, he has been awarded various grants including one from Southeast Missouri State University to complete a project entitled Speaking While Listening, which is an expression, through sculptural installation, of the Vietnam War and its continuing impact.

'The concepts and forms that make up my artwork generate from an interest in melding physical and cultural history into compositions that exhume, analyse and challenge issues from yesterday and today. Through an assortment of media, I create artwork that compiles and preserves information into layered, stacked and eroded forms. The finished product most often references the link between geology, history and everyday life, such as social stratification, political fissures, or historical sedimentation and erosion.'

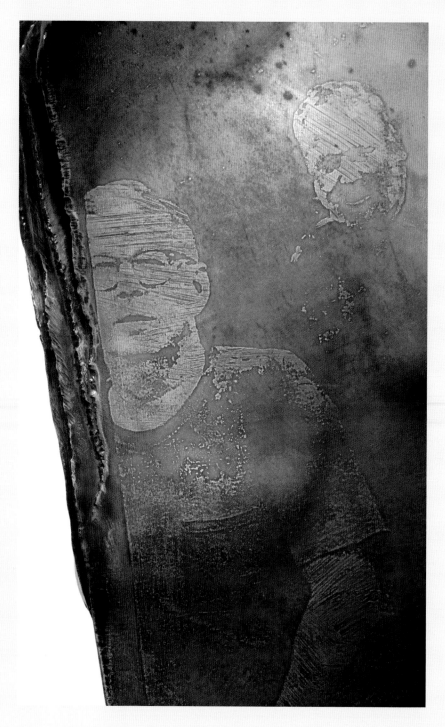

ABOVE AND LEFT Chris Wubbena, *3:30*, 121.9 x 61 x 10.2 cm (48 x 24 x 4 in.). 'I used photo emulsion on silkscreen and after exposing and rinsing out an image, I screened condensed milk directly on to the flat steel and let it dry. Then I brushed asphaltum (an acid-resist ground) over the dry milk and let it dry. I soaked the steel by placing wet paper towels on top of the metal. The milk lifted up and I wiped it away. I spray-painted the back of the steel and put the whole sheet of metal into a strong nitric acid bath. I cleaned off the asphaltum and composed the sculpture from there, welding and grinding ... 3:30 is the time that I, as a child, used to sit with my mother waiting for my father to get off from work. When the whistle would blow, grown men would run out of the factory, jump into their cars and speed away as fast as they could ... The sculpture exists as an imprint of that memory, where the ghosts of the workers are etched into a steel fragment reminiscent of eroded stone, the same metal that they work with day in and day out ... Their only release is at 3:30 when the bell rings.'

BELOW Chris Wubbena, *Hope*, 121.9 x 73.7 x 5.1 cm (48 x 29 x 2 in.). 'Although my wife and I had plans to start a family, the events of September 11th made us rethink bringing a child into a world of such cultural and political violence. However, the more we thought about it, the more it seemed that each problem of the day carries the hope of a new perspective, a fresh outlook: one that is only possible from a child. It is the new generation of learners that can help us create a new history built on the mistakes of the past. *Hope* is a sculpture that was constructed while my wife was pregnant with my son. It is composed of two steel and concrete sides with acid-etched texture on each of their surfaces. It was done with direct scratching into the asphaltum-coated surface of the steel before etching. The centre of the sculpture frames two pieces of paper layered one over the other. The paper behind is imprinted with layered texture pulled directly from both steel surfaces. The paper in front (see below right) is clean or blank – a fresh beginning.'

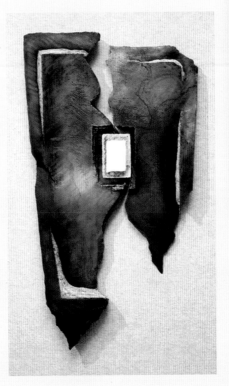

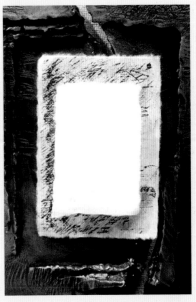

ARTIST PROFILE

PÄIVIKKI KALLIO

My working process is like a rite, in which my methods and materials have a substantial role. In every process I am searching for a new way or path to the heart of printmaking where the basic image, the printing matrix, is transforming itself into something new through printing, reflection, outputting – the final imprint is like a projection. For me, the essence of the printmaking process is dualistic, three-dimensional, conceptual and melancholic.

When looking at prints we are missing the absent matrix. I very rarely use paper for my prints. I have experimented with different materials and lighting over a 20-year period and have made installations from these materials and their immaterial reflections.

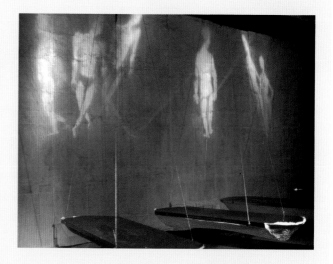

ABOVE Päivikki Kallio, *Valse Triste*, installation with copper plates, tissue paper and spotlights. Made from six plates, each 150 cm x 50 cm x 20 cm (59 x 19¾ x 8 in.).

LEFT Päivikki Kallio, *Sound Images*, installation, etching, record player, spotlights. These two installations are based on the idea of reflection. Etched copper plates were coated with nickel. The etched areas are matte and non-reflective, and the other surfaces are like mirrors: reflective. When the beam of light meets a copper plate, the reflection from it shows the etched image as an immaterial print, a projection from the matrix. And when you move the plates, reflections are swinging and an archaic movie is composed.

LEFT Päivikki Kallio, *Meetings*, installation, 40 x 30 x 20 cm (15¾ x 12 x 8 in.) A photo-resist, ImagOn, was laminated on stone. It was exposed with a negative film and developed. The image is sandblasted through this matrix and it becomes like a gravure image on the surface of the stone. There is no paper in the process.

ARTIST PROFILE

AARON WILSON

Aaron Wilson is a Professor of Art at the University of Northern Iowa, teaching printmaking and foundation courses. His work has centred on the use of non-conventional printmaking formats for over a decade. He regularly employs digital imaging along with combinations of media that lend flexibility to traditional printmaking processes. These techniques allow him to use printmaking in sculptural and hybridised forms, such as installation. The work bridges gaps between two-dimensional and three-dimensional spaces and aesthetic sensibilities. The subject matter in Aaron's work ranges from politics and suburban lifestyle to visual sensation.

Aaron Wilson, *Cash Bar*, mixed media, screenprint on panel, bar equipment, 160 x 228.6 x 45.7 cm (63 x 90 x 18 in.). 'The pop art movement has always inspired me and these pieces clearly quote works from those decades. While I have a reverence for the art from that movement, I don't completely identify with it. Often, I think of Warhol's soup cans, the break with fine art convention they represent, the cool presentation of the printed form and their odd vacuity, knowing all the while they can never be effectively duplicated. Warhol used the multiple to depict the singular image – the soup can, the Brillo box, the celebrity – making them into something monumental and unsettling. In other words, the form of the multiple was used to create the archetypal. Many artists of my generation, inspired by pop [art], approach the equation much from the opposite direction. They use the archetypal as raw material to create something relative and dependent. The difference can be seen this way – the form of the multiple versus the multiplicity of form.'

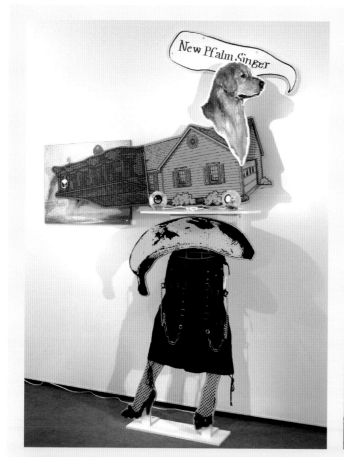

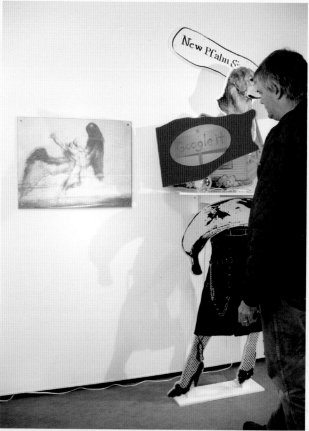

Aaron Wilson, *New Psalm Singer*, mixed media, screenprint on panel, MP3 player and speakers, 157.5 x 218.4 x 40.6 cm (62 x 86 x 16 in.). 'While some of the references in the new work are clearly contemporary, my impetus for making them is more familiar, and joyful, than timely. Nostalgia played some role in how the work came together, but I hope to temper that element with precision rather than romanticism. The works are functional, while not completely familiar. Some of my earliest thoughts on the work characterised them as Frankenstein-like monsters, the physical products of random Google searches.'

Aaron Wilson, *Parlor*, mixed media, screenprint on wood, digital printing on fabric. Installation: variable size. '*Parlor* is a mixed-media installation that seeks to visually depict post-September 11, 2001 America. It combines fine art printmaking processes with digital imaging technology, sculpture, drawing and painting ... Consumer, religious and political entities have all responded to the horror of terrorism, creating a web of relative effects. Auto loans with zero-percent financing, action figures of our President, Internet images of crying eagles, a re-evaluation of our civil liberties, and an ongoing war on terror are all the result of a single event ... I have fashioned a Victorian-styled bench. The bench looks like much of the furniture that was available during the mid-19th century, with lathed spindles and scalloped edges made from wood, but it has been slightly altered to convey meaning. For instance, the bench's spindles are shaped to look like the silhouettes of rifles, knives, bombs and other weapons of terrorism and war. Its flat surfaces contain screenprinted images of scenes from contemporary American culture. Some of these scenes refer directly to the terrorist attack or the following conflicts in Afghanistan and Iraq. Other scenes include pictures of consumer imagery. The result of these manipulations of form may be unsettling. However, the adaptation from a comfortable home furnishing into a vessel for discussion of post-9/11 America is fitting. *Parlor* encapsulates the effects the events have had over the last decade by existing in every aspect of its material objects. This pervasive effect is similar to the way terrorism changed the lives of people worldwide ...'

ARTIST PROFILE

KRISTIN POWERS NOWLIN

For the past 12 years, my work has dealt with issues of race and gender. From my perspective as a middle-class, white Midwestern woman in an interracial marriage, the work challenges the way American culture perceives and judges groups of people, as well as the way groups of people interact with one another. While some pieces intentionally and consciously use stereotypes as a critique of their absurdity, others explore the issues through personal narratives. In these works, the stereotype is reversed so that the text appears on what many viewers might assume to be the 'wrong' face.

Using printmaking and fibre techniques, I explore issues of marginalised subcultures, stereotypes, and coded language. The printed images are composed of marks that are cross-stitch patterns, which involve codes that represent certain colours of embroidery floss, reflecting the way language can correspond to a particular person or group of people. These codes are a visual and conceptual connection to the coded language that is embedded in our culture. In addition to the works on paper, this series includes cross-stitch pieces on fabric created by employing the codes found on the prints. In addition, the fibre pieces not only directly relate to the print, but are created in a similar way; the cross-stitch image is approached one colour at a time as I carefully translate the printed codes into crosses of coloured floss on the fabric. As a trained printmaker, this process of building up an image colour by colour seems only natural. A leap of faith is required in both the printing and the cross-stitching processes, that the image will work out in the end.

Process: The prints were developed first, as they are the pattern for the cross-stitched images. My process involves first finding images that I could use as a starting point for the drawing. Once I selected these, I would draw a value drawing of the image on to paper in graphite with whatever modifications I was doing from the original found photograph. Then I

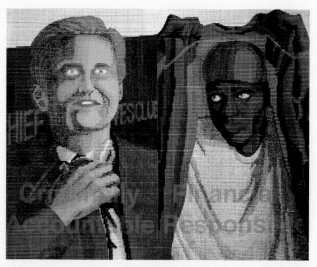

Kristin Powers Nowlin, *Codes: Crime*, 40.6 x 50.8 cm (16 x 20 in.). Silkscreen on paper.

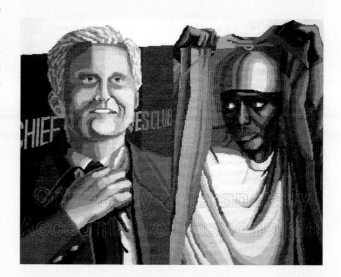

Kristin Powers Nowlin, *Coloured/Coded: Crime*, 40.6 x 50.8 cm (16 x 20 in.). Cross-stitch on fabric. 'These two prints were started shortly after the Enron fraud was exposed. I was thinking about how many lives the corporate 'suits' had messed up and that they probably wouldn't be punished appropriately for the scale of the crime, compared to what might happen when someone like a sports star gets busted for doing drugs or something that probably didn't affect very many other lives. The idea was to contrast the white man in the suit and tie with the African-American man with the jacket over his head as he tries to avoid the cameras. The text was reversed as to what the stereotype might be in some viewers' minds; "Criminally accountable" was printed over the white man's chest, while "Financially responsible" was printed over the African-American's chest.'

would use a light table and hand-draw all the codes for the different-colour areas in the print (* = blue, ^ = orange, etc.), using a rollerball pen on white interleaving paper.

The stack of paper would be the value drawing on the bottom, a sheet with a black line grid in the middle, and the interleaving paper on top. After I completed the drawing of all the codes (this is the black ink layer in both Codes prints), I would use those to make a photocopy to oil up as positive for a photo-silkscreen print.

In the case of Codes: Crime, I first printed flat shapes of colour to correspond with the colour areas in the image, then a blue grid, and then the black codes. In Codes: English (Black) Vernacular, there were no

colour areas printed before the blue grid and the black codes. Both images were then printed with a transparent layer of text on top. On Codes: English (Black) Vernacular, the final step was to stitch small crosses of cross-stitch floss that corresponded to the colour of floss that the code represented in the key along the bottom edge of the print.

After completing the prints, I cross-stitched the images using traditional 18-count cross-stitch fabric and DMC embroidery floss. Because the prints were not actually such small 'pixels', I had to do four stitches for each code on the print. While this complicated things during the stitching process, it seemed faster to me than doing an entirely new drawing to scale.

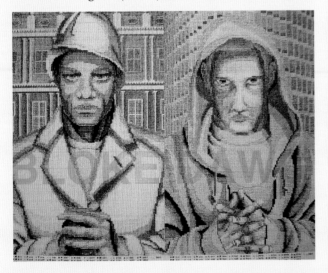 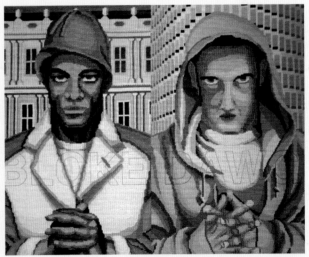

ABOVE LEFT Kristin Powers Nowlin, *Codes: English (Black) Vernacular*, 40.6 x 50.8 cm (16 x 20 in.). Silkscreen and stitching on paper.

ABOVE RIGHT Kristin Powers Nowlin, *Coloured/Coded: Vernacular*, 40.6 x 50.8 cm (16 x 20 in.). Cross-stitch on fabric. Of *Codes: English (Black) Vernacular and Coloured/Coded: Vernacular*, Kristin explains: 'These prints were created for a portfolio in which half of the artists were English and the other half were American. The title of the portfolio was 'Common Language', with the idea that

we share this common language, but that often doesn't really mean we speak the same language at all. 'While I studied abroad in England as an undergraduate student, I was always surprised when a black man in England spoke with an English accent. Of course this reaction was absurd, which even I knew at the time, but I still kept having that feeling. This print was my attempt to try to reveal that feeling to the viewer, as well as to kind of express that idea that we really do speak two different languages. I decided to show two rap artists, one black and one white. Then, I reversed the urban settings behind so that the white rap singer

was in front of what might look more like New York and the black singer was in front of what might look like London. In addition, the text was reversed so that 'Dawg' appeared on the white New York artist and 'Bloke' appeared on the black London singer. I also decided to use less colour on this print so that the colour would really only appear in the stitching, both at the bottom of the print in the key as well as on the actual cross-stitch on fabric. For this reason, the cross-stitch and print in this pairing are more noticeably different than in the other pair.'

Glossary

À la Poupée (with a dolly) Applying different colors of ink to different sections of a plate with your fingers, daubers, or bunched up pieces of cloth (the dollies). Each area is then carefully wiped in such a way that the colors are kept separate and only merge at their edges.

Baren Used to transfer ink from a relief plate or a carved block to paper through rubbing.

Bon à tirer Pull all prints to match the first proof that satisfies you. This proof is called the *bon à tirer*.

Brayer A small hand roller.

Burnisher Polished curved metal tool. Use with pressure and a drop of oil to smooth unwanted areas of a metal plate.

Burnt copper plate oil Raw linseed oil heated to a high temperature and used to mix, condition and change the viscosity of a printing ink.

Calcium carbonate Made from limestone. Used as the powder base in most non-abrasive powdered and cream cleansers and toothpastes. Used in polishing and degreasing copper plates. Also used in the form of Soft Scrub or Ecover cream cleansers to clean toner scatter, fingerprints and ink scum from polyester litho plates.

Carborundum grit Silcon carbide powder normally used to grain and level lithography stones. Can be added to acrylic gel mediums to create a mixture that can be applied to a matrix. When dry its rough texture will hold ink and print a tone.

Citra-Solv A natural, organic d'Limonene-based (from orange peels) cleaner and degreaser. In its concentrated form it is an excellent solvent for making toner transfers from photocopies and laser prints.

Chine collé Method for adhering thin pieces of colored paper to a print as the image is printed.

Collagraph Considered a form of intaglio (italian, meaning to 'cut into'). Depressions, intended to hold ink and to be printed onto paper, are created on a matrix. The processes used are gluing, cutting, and surface building on to a matrix of cardboard, hardboard, Plexiglas/Perspex or metal.

Cotton bud Q-tip in the US.

Drypoint An intaglio technique where a sharp tip is used to scratch marks on a plate. The burr that is raised will hold ink and print a soft velvety line.

Durometer Term that indicates the hardness of a roller. The term 'shore' is used in the UK.

Fountain solution A mildly acidic solution (in its diluted form) used to dampen and clean lithography plates.

Intaglio From the italian, meaning to 'cut into.' The depressions created on a matrix hold ink and can be transferred to paper using an etching press.

Lithography A planographic printing process (printing from a flat surface) dependent upon oil and water not mixing.

Magnesium carbonate A white powder used to add body or stiffness to printing inks and to lower their gloss.

Matrix In printmaking the base material that carries the print information.

Monoprint A unique print made with or from a repeatable matrix.

Monotype A unique print made from a flat surface rolled and painted with ink. Subtractive processes may also be used. No repeatable matrix is used in its creation.

Mounting board Matboard in the US. A flat board made of paper from which mats are cut. Mats are used to surround an artwork and to separate it from the glass of a frame. Excellent matrix for collagraphs.

Relief Any printmaking plate that is surface rolled can become a relief print. Normally refers to woodcuts and linoleum cuts. The cut-away areas of these blocks do not print.

Perspex Plexiglas in the US. Acrylic sheet.

Rainbow roll (split fountain) Refers to a process by which two or more softly blended colors of printing ink are simultaneously rolled onto a flat non-porous or relief surface. This surface is then transferred to printing paper via the press.

Scalpel Very sharp, small knife. In the US an X-acto or matknife. For printmaking it is used to cut stencils and for cutting and scoring mounting (mat) board and illustration board for collagraphs.

Scraper A three-sided, steel tool with sharpened edges used to scrape away areas of a metal plate in the process of removing unwanted marks. Can be used alternatively to add texture that will hold ink.

Screenfiller A liquid used in screenprinting to block the screen from printing ink. It is acrylic based and can be used as a very diluted mixture to image a polyester litho plate.

Scrim Tarlatan in the US. A stiff cheesecloth-like material used to wipe excess ink from intaglio plates.

Shore Term that indicates the hardness of a roller. The term 'durometer' is used in the US.

Soft Scrub A non-abrasive cream cleaner; comparable to Cif or Ecover cream cleaners in the UK. Useful in the processing and cleaning of polyester litho plates.

Substrate The surface which receives a print, normally paper. May also be used to denote the material on to which a monoprint is created or a collagraph is built as in the layer under another.

Tarlatan Scrim in the UK. A stiff cheesecloth-like material used to wipe excess ink from intaglio plates.

Viscosity Refers to the stiffness of an ink. A stiffer ink is more viscous. A looser ink is less so.

Suppliers

UK

AP Fitzpatrick
www.apfitzpatrick.co.uk
General art supplies including Lascaux Screen Filler

ArtStore
www.artstore.co.uk
General art supplies including Softcut printing blocks

Sources for Citra-Solv Concentrate:
www.ecohip.co.uk
and
www.greenhealthwatch.com

Intaglio Printmaker
www.intaglioprintmaker.co.uk
General printmaking supplies including anti-skinning spray, Speedball Screenfiller, Economy rollers

John Purcell Paper
www.johnpurcell.net
Paper

Rollaco Engineering
www.rollaco.co.uk
Printmaking rollers and inks

R. K. Burt and Company Ltd
www.rkburt.co.uk
Paper

T. N. Lawrence and Son Ltd.
www.lawrence.co.uk
General printmaking supplies and paper, including Speedball Screenfiller and rollers, Softcut printing blocks, Economy Lino Cutters, Speedy-Stamp blocks

USA

Daniel Smith Inc.
www.danielsmith.com
General printmaking supplies and paper

Graphic Chemical and Ink Co.
www.graphicchemical.com
General printmaking supplies and paper

McClain's Printmaking Supplies
www.imcclains.com
Relief printmaking supplies

Renaissance Graphics
www.printmaking-materials.com
General printmaking supplies and paper

Takach Press
www.takachpress.com
General printmaking equipment and supplies including Citra-Solv Concentrate

Z-Acryl Printmaking
www.zacryl.com
Polyester litho plates, magnetic registration template

Bibliography and further reading

Ayers, Julia, *Monotype, Mediums and Methods for Painterly Printmaking* (New York: Watson-Guptill, 2001)

Brooks, Catherine, *Magical Secrets about Line Etching & Engraving: The Step-by-Step Art of Incised Lines, with an Appendix on Printing by Kathan Brown* (New York: Crown Point Press, 2007)

Brown, Kathan, *Magical Secrets about Thinking Creatively: The Art of Etching and the Truth of Life* (New York: Crown Point Press, 2006)

Clemson, Katie and Simmons, Rosemary, *The Complete Manual of Relief Printmaking* (New York: Alfred Knopf Inc., 1988)

Grabowski, Beth and Fick, Bill *Printmaking: A Complete Guide to Materials and Processes* (London: Laurence King Publishing Ltd, 2009)

Hartill, Brenda and Clarke, Richard *Collagraphs and Mixed-Media Printmaking* (London: A&C Black, 2004)

Hoskins, Steve, *Inks* (London: A&C Black, 2004)

Martin, Judy, *The Encyclopedia of Printmaking Techniques* (Philadelphia, Running Press, 1998)

Newell, Jackie and Whittington, Dee, *Monoprinting* (London: A&C Black, 2006)

Oxley, Nigel *Colour Etching* (London: A&C Black, 2007)

Reddy, N. Krishna, *Intaglio Simultaneous Color Printmaking: Significance of Materials and Processes* (New York: State University of New York Press, 1988)

Roberts, George, *Polyester Plate Lithography* (Boise: Writers Press, Inc., 2001)

Romano, Clare and Ross, John, *The Complete Collagraph: The Art and Technique of Printmaking from Collage Plates* (New York: The Free Press, 1980)

Romano, Clare, Ross, John and Ross, Tim, *The Complete Printmaker: Techniques, Traditions and Innovations* (New York: The Free Press, 1990)

Romano, Clare and Ross, John, *The Complete Relief Print* (New York: The Free Press, 1974)

Stobart, Jane, *Printmaking for Beginners* (London: A&C Black, 2001)

Westley, Ann, *Relief Printmaking* (London: A&C Black, 2001)

Whale, George and Barfield, Naren, *Digital Printmaking* (London: A&C Black, 2001)

HELPFUL WEBSITES:
www.eastlondonprintmakers.co.uk
www.edinburgh-printmakers.co.uk
www.kevinhaas.com
www.nontoxicprint.com
www.northernprint.org.uk
www.printmakerscouncil.com
www.printshop.org
www.re-printmakers.com
www.scottkolbo.com
www.worldprintmakers.com

Index